C000184162

BRUNEL
IN BRISTOL

JOHN CHRISTOPHER

AMBERLEY PUBLISHING

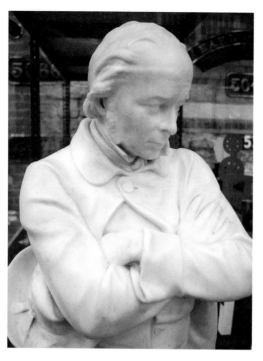

Instead of the familiar photograph of Brunel in later life, standing in front of the chains during construction of the *Great Eastern*, this figurine depicts the engineer as a young man and minus his stove-pipe hat. It is uncertain when IKB first came to Bristol, but it is thought to have been in 1828 when he was just twenty-two years old.

About this book

Hopefully this book will encourage you to delve a little deeper into IKB's works in Bristol, but please note that some sites may be on private property and access might be restricted for reasons of safety and security.

First published 2013

Amberley Publishing
The Hill, Stroud
Gloucestershire, GL5 4EP

www.amberley-books.com

Copyright © John Christopher , 2013

The right of John Christopher
to be identified as the Author of this work
has been asserted in accordance with the
Copyrights, Designs and Patents Act 1988.

ISBN 978 1 4456 1885 2
E-book ISBN 9781 4456 1864 7

All rights reserved. No part of this book may be reprinted or reproduced or utilised in any form or by any electronic, mechanical or other means, now known or hereafter invented, including photocopying and recording, or in any information storage or retrieval system, without the permission in writing from the Publishers.

British Library Cataloguing in Publication Data.
A catalogue record for this book is available from the British Library.

Typeset in 9.5pt on 12pt Celeste.
Typesetting by Amberley Publishing.
Printed in the UK.

Bristol and Brunel

Bristol and Brunel, the two are inseparable. What would the Avon Gorge be without the slender lines of the suspension bridge? The Floating Harbour without the Great Britain sitting in the dry dock where she was built, or the magnificently named Great Western Railway without Temple Meads station? Quite clearly that greatest of the Victorian engineers, Isambard Kingdom Brunel – the 'Little Giant' in the stove-pipe hat – has contributed more iconic landmarks to the cityscape than anyone else. And in return Bristolians like to claim Brunel as their own, an 'adopted son' of the city. But the reality is not so clear cut and it would appear that he only came west by chance. By accident, literally.

There is no documented evidence of when Brunel first arrived in Bristol. Generally it is agreed that he came to the city as part of his recuperation following the flooding of the Thames Tunnel on 12 January 1828. The young Isambard, not yet twenty-two at the time, had been supervising work on his father's project to construct a tunnel going underneath the river between Wapping and Rotherhithe. Typically he was in the thick of it, working on the tunnelling shield at the face of the excavation, when disaster struck. He later recalled, 'The roar of the water in a confined space was very grand, cannon can be nothing to it'. The rush of water was so strong that it carried him along the tunnel and up to the lip of the access shaft where he was plucked to safety. He survived, although he had received serious injuries to his leg and internally, but six others died, including four workmen who had reached the ladders only to be sucked back by the column of water as it receded.

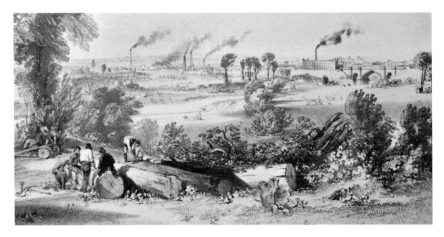

Bristol on the dawn of an era of enormous commercial growth. This view looking towards the city from the eastern side shows the railway bridge crossing over the Avon on the right-hand side, with the truncated tower of St Mary Redcliffe on the left. It comes from J. C. Bourne's *Great Western Railway* published in 1846.

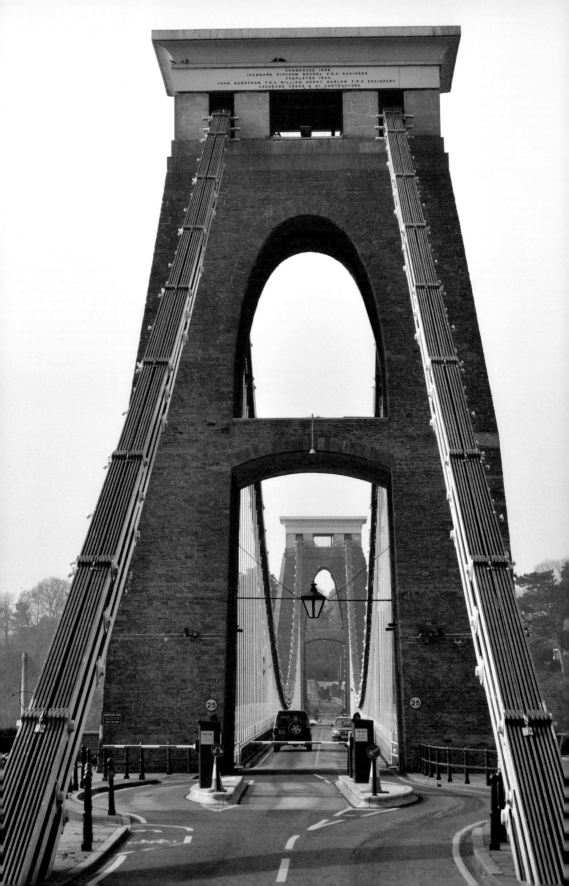

Isambard was packed off to Brighton at first, and then to Bristol. Although the first written reference to his presence in the city does not appear until an entry in Marc Brunel's diary in January 1830, it is generally accepted that Isambard been visiting for about two years before that. The key moment in his relationship with Bristol came in 1829 with the announcement of a competition to build a bridge across the Avon Gorge. This was organised by Bristol's Society of Merchant Venturers, a powerful body made up of the city's most influential figures. Brunel went on to win the competition at the second attempt – see the first section of this book – and through his new network of Bristolian contacts, many of whom became close friends, he went on to work on a number of engineering projects connected with the city over a period of almost twenty years. This was an important time for Bristol which was experiencing great commercial and industrial growth on the one hand, while struggling to maintain its status as a major port on the other.

Even though Bristol played an important part in Brunel's life he never had a home in the city, preferring instead to live and maintain his practice at Duke Street in London. That is not to undermine his loyalty to Bristol as the city which launched his career, as demonstrated in one of his letters written in 1845:

> I have no wish in the matter whatsoever except the old and strong wish of being considered a Bristol man and one who can always be relied on as sticking to his friends thru' thick and thin.

That relationship with Bristol and his friends was not always an easy one, especially if friendship and business were mixed. When several of Brunel's schemes turned sour – in particular the defeat of the broad gauge and the failure of the Great Western Steamship Company – it left many investors and backers in financial difficulties. But for two decades the city and the engineer enjoyed a symbiotic relationship with the one feeding the successes of the other. The long term result is the greatest concentration of Brunel's works to be found anywhere.

Brunel in Bristol is about rediscovering the Brunel on *your* doorstep.

Brunel's Bristol

At the time of IKB's activities in Bristol the city lay, for the most part, to the north of the Avon and within the county of Gloucestershire. The southern side of the river was in Somerset, hence the Clifton Suspension Bridge spanned the two counties. Since then there have been assorted changes to county and city boundaries and associated administrative areas, most notably in 1974 with the creation of the County of Avon, and in 1996 when the City of Bristol became a unitary authority area. The territory covered in this book ignores county lines and focusses on Bristol itself, plus an extended area of a further two mile radius extending beyond the edge of the city to encompass particular locations of interest at New Passage, Yate, Saltford and Flax Bourton. *Brunel in Gloucestershire* was covered in the first volume of this series.

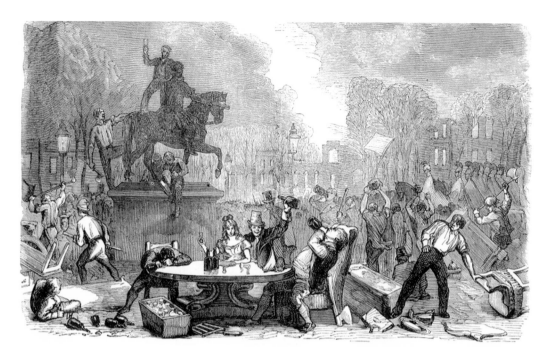

In 1831 Bristol was a riot and IKB enrolled as a special constable. The riots were prompted partly in opposition to the proposed Reform Bill, but also out of a resentment of the power held within in the city by a small elite, as epitomised by the Society of Merchant Venturers. Rioters ransacked the Mansion House in Queen Square and several buildings were razed to the ground. The ensuing unrest and financial uncertainty caused subscriptions for the Clifton Suspension Bridge project to dry up.

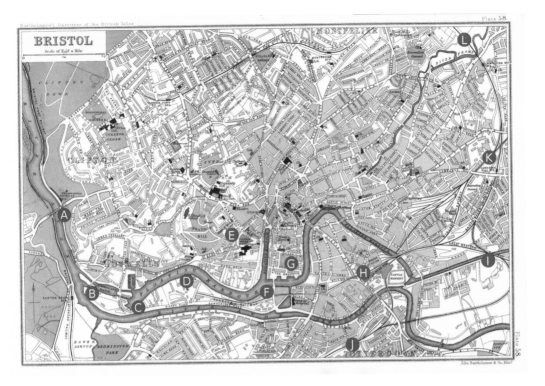

Map of principle Brunel sites in Bristol

A: Clifton Suspension Bridge.
B: South Entrance Lock into Cumberland Basin.
C: Underfall Yard.
D: Great Western Dock where the *Great Britain* was constructed.
E: St George's Street, site of the former Royal Western Hotel.
F: Former site of Patterson's shipyard where the Great Western steamship was constructed.
G: Queen Square, a flashpoint in riots of 1831.
H: Temple Meads railway station.
I: GWR line and railway bridge over the River Avon.
J: Route of the Bristol & Exeter Railway.
K: Route of the Bristol & Gloucester Railway.
L: Route of the Bristol & South Wales Union Railway.

Right: Portrait of Brunel painted by his brother-in-law, John C. Horsley.

7

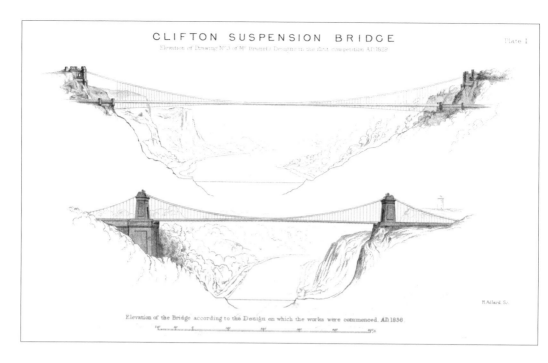

Plate I

Elevation of Drawing N°.3 of M[r] Brunel's Designs in the first competition A.D.1829

Elevation of the Bridge according to the Design on which the works were commenced. A.D.1836

H.Adlard. S[c].

Uppermost: IKB's No.3 drawing entered in the first the Clifton Suspension Bridge competition in 1829. Note how the catenary cables descend below the deck, a device designed to provide stiffness to the deck. It was adopted from his father's suspension bridge on the Isle of Bourbon. The other two illustrations show the 'Egyptian thing' which was finally accepted by the bridge committee after the second competition. There was some debate concerning whether the sphinxes should face outwards to greet the bridge users, or inwards to face each other across the gorge.

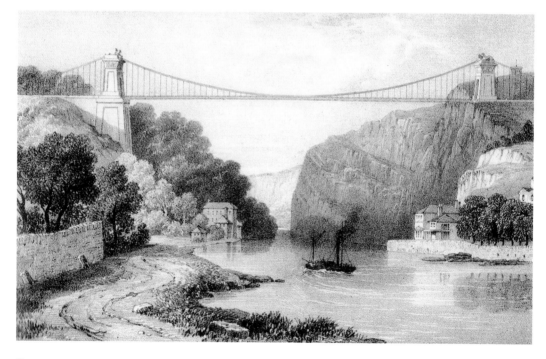

Clifton Suspension Bridge

The Clifton Suspension Bridge which spans the spectacular Avon Gorge has become an instantly recognised symbol for the city of Bristol and the lasting legacy of its adopted son, Isambard Kingdom Brunel. The bridge was Brunel's first major commission. (He had inherited his role on the Thames Tunnel project by virtue of being his father's son.) Yet it was very nearly destined to be left only partially built, the abandoned towers remaining the most visible monuments to one of the engineer's great unfinished works, and even when it was completed the bridge's Brunellian credentials are not as solid as you might expect!

The first proposals for a crossing over the Avon Gorge had appeared some fifty years or so before Brunel was born. In 1754 a prosperous wine merchant named William Vick got the ball rolling by bequeathing the sum of £1,000 which was to be invested until it grew to £10,000 when it would be used to fund the construction of a stone or masonry bridge. By the start of the nineteenth century Clifton village had become a fashionable place for Bristol's wealthy merchants, and it was the appropriately named William Bridges who published the next proposal for a very grand bridge. This extraordinary structure would have filled the gorge like a stone curtain, its five storeys containing houses, a granary, corn exchange, chapel and a tavern, all of which were to be surmounted by a lighthouse. It was more like a vertical village than a bridge, and inevitably this impossibly expensive design was never realised.

By 1829 the Vick legacy had grown to the intended £10,000 mark and Bristol's merchants decided to push ahead with a bridge. They quickly discovered that a stone-built one would cost more like £90,000, and taking account of recent advances in bridge construction – in particular the use of wrought iron – they advertised a competition to design a suspension bridge. The young Isambard Kingdom Brunel threw himself into the task and submitted four of the twenty-two entries received by the closing date. His drawings depicted bridges at slightly different sites on the gorge, and featured single spans ranging from 760 ft (232 m) to 1,180 ft (329 m) in length. This was far in excess of any suspension bridge then in existence. Telford's Menai Bridge, for example, had a main span of 600 ft (183 m) while Marc Brunel's suspension bridge on the Ile de Bourbon had two spans, each one just under 132 ft (40 m).

Of IKB's designs for Clifton two had conventional towers perched on the edge of the cliffs, while the others showed shorter towers with the roadway carved through the rocks and incorporating the opening of the existing 'Giants Cave' in the side of the cliff on the Clifton side. With an artistic eye and a sense of theatre Brunel wanted to capitalise on the drama of the location:

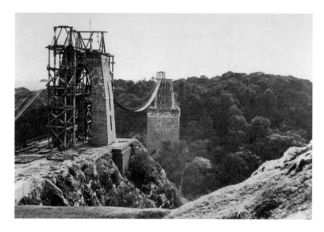

The bridge was only completed after Brunel's death.

Left: The first of the chains is in place. Where they passed over the towers they were not fixed in position, but instead passed over rollers to allow for movement.

Below: Detail of the Egyptian-style capping on the Clifton tower. This feature can be found in examples of IKB's work elsewhere.

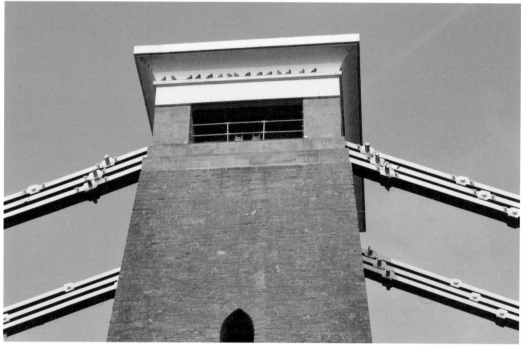

There are several differences between the two towers. The one on the Clifton side, for example, has side apertures or piercings and squarer edges, while the one on the Leigh Woods side has several courses in a lighter stone. To create a better visual balance IKB made the Clifton end of the bridge very slightly higher than the Leigh Woods end.

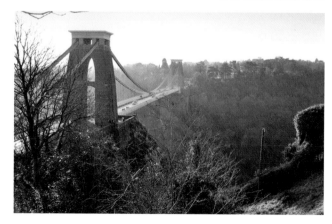

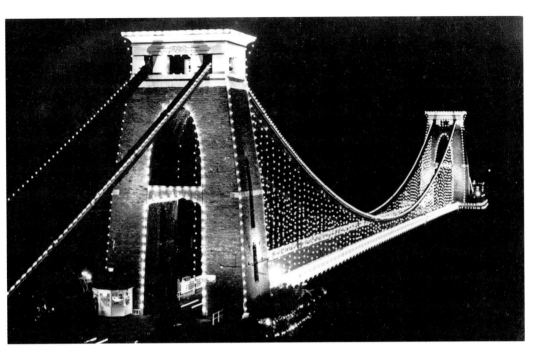

The bridge has always been illuminated. At first with magnesium flares, although these tended to blow out, and since the 1930s by electric lights. The chain bulbs were added to mark the Queen's coronation in 1953, and to commemorate the bicentenary of Brunel's birth in 2006 the lighting was upgraded. There are now 3,000 small light-emitting-diodes (LEDs) on the chains, with fluorescent lighting for the walkways and additional low-level lighting on the towers and abutment. *Below*: The LED housings can be seen dotted along the chains in this 2013 photograph.

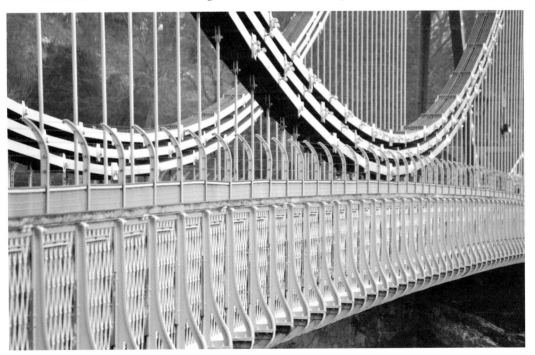

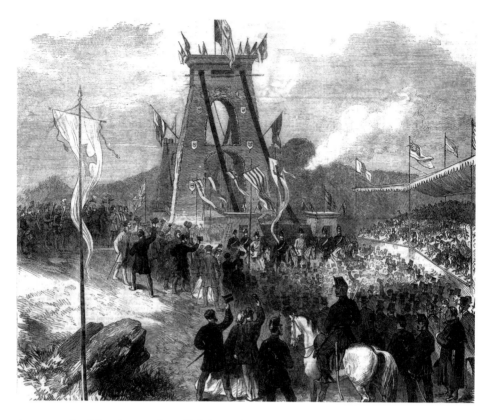

A scene of celebration at the official opening ceremony on 8 December 1864. During Brunel's lifetime there was every expectation that the bridge would never be completed, and there were even calls for the towers to be torn down. *Below*: IKB's pedestrian suspension bridge over the Thames, linking the south bank with the Hungerford Market on the north side, was dismantled after the market closed in 1859. The chains were reused at Clifton, supplemented by an additional third chain.

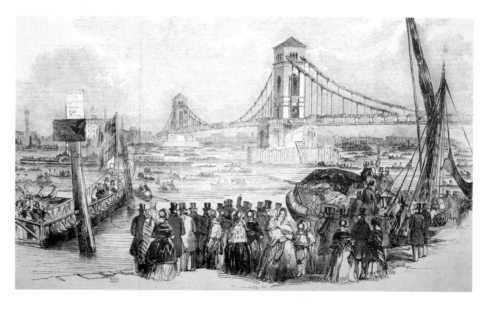

I thought that the effect ... would have formed a work perfectly unique ... the grandeur of which would have been consistent with the situation.

Correspondence from 1829 has recently come to light which shows how much Isambard had sought his father's advice on the design of the bridge. Marc Brunel was concerned that his son's plans for a single span were too ambitious. He wrote to him saying that it 'needed something in the middle to support' and added, 'you should do it like this', enclosing a sketch with a towering pagoda splitting the gorge and the span into two. Of course Isambard would have none of it.

The bridge committee invited the seventy year-old Thomas Telford to judge the entries and he promptly rejected the lot of them. Instead he submitted his own design for a three span bridge with two lofty Gothic towers rising 260 ft (79 m) from the bottom of the Gorge on either bank of the Avon. It was, proclaimed the *Bristol Mercury* in February 1830, a 'singularly beautiful design'. Brunel did not agree and responded sarcastically:

As the distance between the rocks was considerably less than what had always been considered as within the limits of which suspension bridges might be carried, the idea of going to the bottom of such a valley for the purpose of raising expense for two intermediate supporters hardly occurred to me.

He was absolutely right. Telford's towers would have been absurdly costly and in the end the bridge committee did what committees do best, they fudged it. While publicly expressing their admiration of Telford's Gothic masterpiece, they privately reopened discussions and later in 1830 a second competition was announced. Another ragbag of designs was submitted, including some which entirely ignored the stipulation that it was to be a suspension bridge. William Armstrong proposed a single span girder bridge with masonry viaducts to either side, while C. H. Capper put forward a Telford-lookalike with twin towers in a rustic style. Brunel hedged his bets and submitted another four designs. The first was a reworking of the Giant's Cave theme. The second and third reduced the span to a more acceptable 720 ft (219 m) by introducing a masonry abutment protruding from the Leigh Woods side, while the fourth pandered to Telford's prejudices by including a pair of simplified towers rising from the river bank and finished in an Egyptian style.

Unbelievably, to Brunel at least, his design came only second in a short-list of four, and all of them were criticised by the judges. Unwilling to accept second place Brunel berated the committee until a modified version of one of his entries was accepted. He referred to it as the 'Egyptian thing' and it featured two towers capped with sphinxes, with the tower on the Leigh Woods' side resting on an abutment. In June 1831 a ceremony was held to mark the

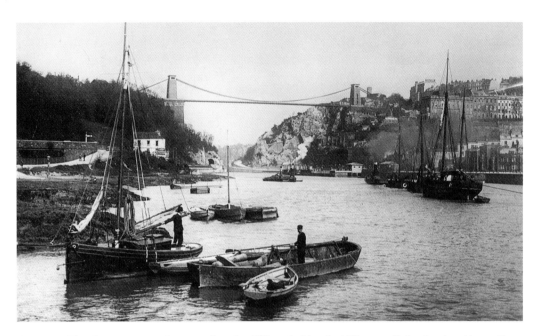

Opposite: The deep gorge makes crossing the Clifton bridge feel like a walk in the sky. *Above*: Even without its sphinxes the bridge has been Bristol's most recognisable landmark for a century and a half. This photograph from, *c.* 1910, is from Rownham Ferry at high tide.

commencement of construction and the foundation stone was laid in August 1836. However, by 1843, with the towers standing ready to receive the chains, the money ran out and work was halted.

For the next two decades the towers loomed over the Avon Gorge like forlorn gravestones to the unfinished bridge. To Bristolians they were known as 'Brunel's follies'. In 1851 the chains intended for the bridge were bought by the South Devon Railway Company and incorporated within the Royal Albert Bridge at Saltash which was completed shortly before Brunel died in 1859. At the time of his death there were calls for the towers to be removed, but in the event his fellow engineers at the Institute of Civil Engineers decided to complete the bridge as a monument to their late friend and colleague. John Hawkshaw, the engineer behind the new Charing Cross railway bridge being constructed on the piers of Brunel's old Hungerford Bridge on the Thames, together with W. H. Barlow, wrote a feasibility study showing how the Hungerford chains could be used to complete the Clifton Bridge. There would, however, need to be several significant changes to Brunel's design. Firstly the Sphinxes and the fine Egyptian decoration on the towers were out. The deck of the bridge was widened from 24 ft (7.3 m) to 30 ft (9.1m) and Barlow added two longitudinal wrought-iron girders to support it. In addition the suspension chains from the Hungerford Bridge were strengthened with the addition of a third chain, and the system of anchoring the chains into the ground was beefed up.

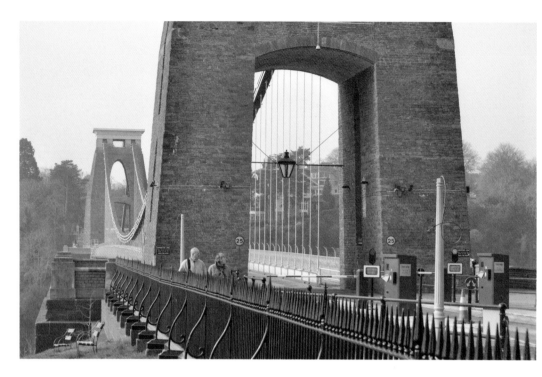

Looking across the bridge from the Clifton side. Motorists have to pay a small toll but cyclists and pedestrians pass for free. The chains are anchored deep within the ground on either side of the bridge. *Below*: At the Leigh Woods end a pair of gate houses mimic the shape of the towers. The visitor centre is located just off picture to the right.

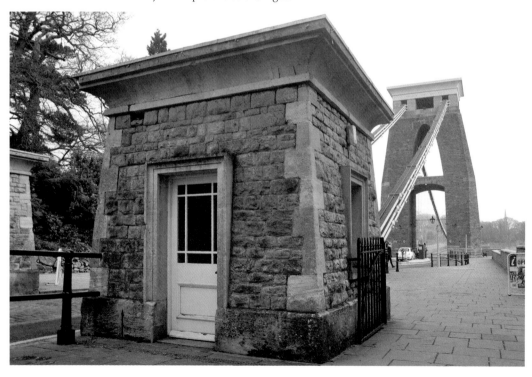

Work recommenced at Clifton in 1863 and it was only eighteen months later, on 8 December 1864, that the bridge was officially opened to a cacophony of brass bands, cheering crowds, church bells and the firing of a field gun salute. In its final form the bridge might not be quite to Brunel's making, but it fits and enhances the setting of the Avon Gorge like an exquisite piece of jewellery.

Since 1952 the bridge has been looked after by a trust. To cover its upkeep, car drivers pay a modest toll, while pedestrians and cyclists have crossed for free since 1991. In 2006 Bristol became the focus of the Brunel 200 celebrations which included a number of events in the city. The Clifton Suspension Bridge was treated to a new lighting system with 3,000 light-emitting-diodes installed to illuminate the chains, plus low-level floodlighting for the towers and abutments. On the night of 9 April 2006, the bicentenary of his birth, the bridge became the perfect launchpad for a spectacular fireworks display that lit up the gorge with chains of light and colour.

Explore the Clifton Suspension Bridge

• There is a toll for cars, but pedestrians and cyclists travel free. A visitor centre has been created on the Leigh Woods side of the bridge. (OS map 172, ST 565732)

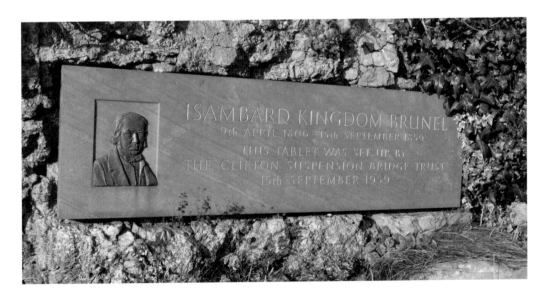

This commemorative plaque was installed in 1959 on the Clifton side of the bridge to mark the centenary of IKB's death.

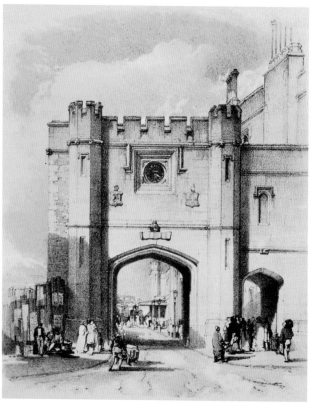

The frontage of the GWR station at Temple Meads is best described as Tudoresque, a style much favoured by IKB for his earlier railway works. There were booking halls and public facilities on the ground floor, with additional offices and the directors' meeting room on the upper levels. Travellers, arriving by foot or horse-drawn vehicle, entered the station via the archways on the left.

The clock in a prominent position above the main arch showed 'railway time' which was first introduced by the GWR to ensure that the railway ran to a universal timetable rather than local time. In Bourne's illustration note the coat of arms for the two cities, Bristol and London. The line was originally referred to as the Bristol Railway and it was Brunel himself who first called it the Great Western Railway.

Temple Meads and the GWR

The plan for a Bristol Railway to London was first proposed in 1832 and Brunel submitted a tender to conduct the survey work the following February. In August 1833 he was confirmed as engineer to the line and for the first time he recorded in his journal the title 'Great Western Railway'. Brunel was adamant that his railway would be unlike any other. It had to be the best, not a carbon copy of the existing northern railways. His passengers were of an entirely different calibre; they were 'persons living upon their incomes' and he would ensure that they could take their coffee while travelling at 45 mph. Working with a blank sheet of paper he proposed building the line to a bigger gauge than used by George Stephenson who had adopted the existing gauge of just over 4 feet 8 inches used by the northern collieries. Brunel's railway would be built to his own broad gauge, with the rails just over 7 feet apart.

The Bill for the construction of the GWR first went before Parliament in early 1834, but was thrown out by the House of Lords because of concerns about the proposed site for the London terminus at Victoria. The following year the company went back with an alternative proposal to share access into London with the London & Birmingham Railway to a joint terminus at Euston. That plan was later abandoned in favour of an independent terminus at Paddington. The GWR received Royal assent on 31 August 1835. Unusually there were two boards of directors, one for the London end and one for Bristol, and the plan was to construct the line from both ends. As a result many of the landmark works on the railway have a distinctly different flavour at either end of the line, both the stations and such features as the tunnel portals. Because arrangements for the land at Paddington had not been finalised the London terminus was to be a temporary wooden-built affair, while the Bristol station – the first purpose-built railway terminus in the world – was intended to impress and stood as an statement of the company's solidity.

Brunel's GWR terminus at Temple Meads opened on 31 August 1840. It is situated to the left of the present station approach, with a frontage of Gothic-Tudor stonework facing out on to Temple Gate, the A4 road to Bath. The GWR's coat of arms – a union of those of Bristol and London – can still be made out at the top of the building, and it was here, above the ground floor booking hall, that the offices and directors' boardroom were located for the Bristol part of the company. Passengers arriving by horse-drawn carriage entered the station through an arch on the left-hand side, flanked by a smaller arch for those on foot. In the circle above the main arch there was a clock which showed the railway's standard time, introduced to prevent passengers missing their trains. (Prior to this Bristol time, based on the position of the sun, was some ten minutes behind that of London.) Passengers would then enter the lower level of the station, passing under the tracks, where steps led up to the booking hall,

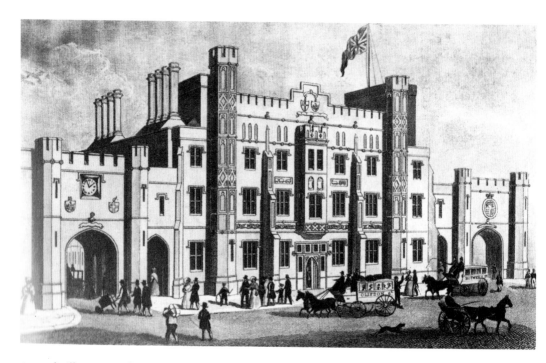

An early illustration showing travellers arriving at the station. Horse-drawn vehicles entered the nearest arch, passed under the track and emerged to exit on the far archway, now demolished. *Below*: The view through the remaining arrival arch with a sign from the time when the engine shed was occupied by the British Empire and Commonwealth Museum. On this side of the station the street level is below that of the track.

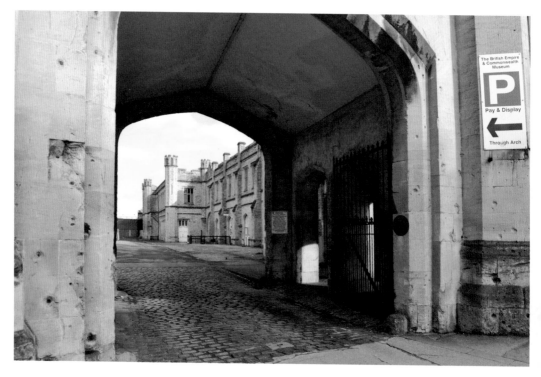

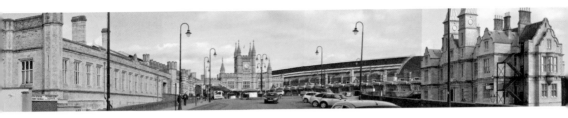

offices, waiting rooms and the platforms. They exited via a matching arch on the right-hand side of the building, since demolished. Inside the passenger station, or shed, travellers were astounded by the loftiness and lightness of the building. J. C. Bourne describes it as being:

> Occupied by five lines of railway, covered by a timber roof of 74 ft span, pierced with skylights and ventilating funnels, and in a style of architecture suited to the exterior of the building. It is separated by a row of iron columns and flat arches from the aisles, which are occupied as platforms for the arriving and departing passengers, and are lighted by a range of windows along the outer wall. The east end of the shed is open to receive the Railway ...

Bourne's portrayal of the interior of Temple Meads is probably the most famous of his lithographic prints and it accurately shows the distinctive mock-hammerhead beams; a purely decorative feature which has no structural function. Beyond the colonnade of flat-topped neo-Tudor arches the outer wall was pierced by a row of rectangular unglazed window openings which provided ventilation for the passenger shed. Further ventilation was later added in the apex of the roof for the smoke and steam to escape.

Above: Panoramic view of the approach into Temple Meads with Brunel's terminus on the left, the Victorian clock tower central, and B&ER building to the right. *Below*: Side view of the old station. The engine shed was immediately behind the office block and the passenger shed is on the far right.

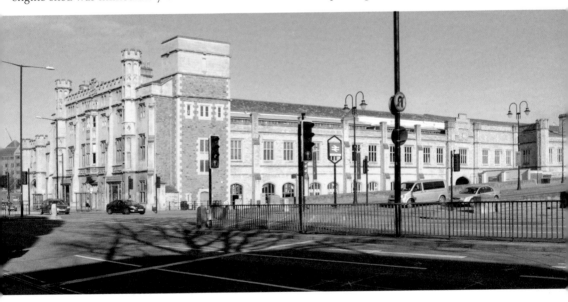

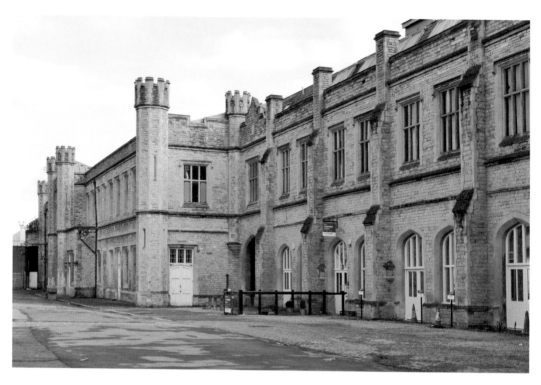

The western face of the station is seldom seen by modern day travellers. Horse-drawn vehicles entered the central archway to pass under the track/platform level which is at first storey height on this side. *Below*: It might look like another tower, but the rectangular block rising above the office building is actually a water tower to supply the engines shed below.

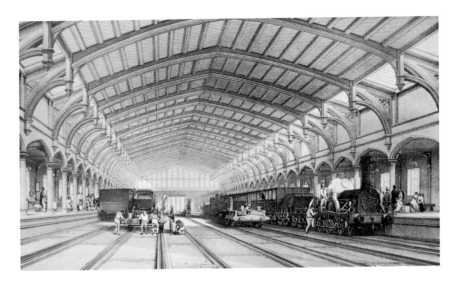

J. C. Bourne's famous view shows the hammerhead beams and wide timber roof, and at the back the lower roofed area of the engine shed. Note the broad gauge loco, and manhandling of the wagons including one carrying a carriage. It was not uncommon for wealthier passengers to take their carriages with them.

The engine shed was at the end of the tracks, sandwiched between the passenger shed and the office block. Because this was a terminus in the true sense of the word, incoming engines had to be revolved on a turntable at the rear of the shed to point them back the right way for departures. Beneath the tracks there were openings down to the brick-vaulted cellars, and ash and clinker from the locomotives would be racked out and dropped into trucks on the lower level. Another reminder that this was a functional railway building can be found on the roof where a large water tank rises up like a rectangular tower.

In order to handle increasing levels of rail traffic the station was extensively extended between 1871 and 1878. The design of the 'new' Temple Meads building is widely attributed to Brunel's collaborator, Sir Matthew Digby Wyatt, who had previously worked on the architectural detailing at Paddington and on the workers' village at Swindon. However there is little corroborative evidence to back this up and it has been suggested that it might have been the work of Francis Fox who was the engineer of the Bristol & Exeter Railway. The overall design of the new Temple Meads reflects Brunel's original in many ways, in particular the use of ashlar together with dressed Bath stone, and the repetition of detailing such as the crenelated roof parapets and miniature corner turrets. However it also responds to the popular taste for the Barry/Pugin Perpendicular Gothic architecture of the Palace of Westminster building, which had been completed in 1870. You get a flavour of this in the prominent centre piece of the new Temple Meads, the clock tower which rises above the entrance and was originally capped by a tapered, steep-sided roof. Damaged by fire bombs in the Second World War this useless adornment was never replaced. Brunel's

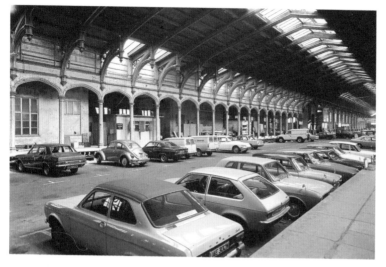

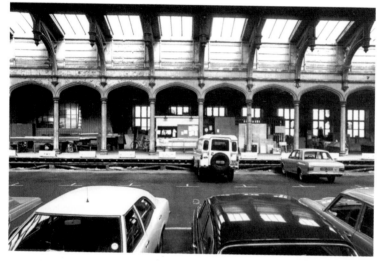

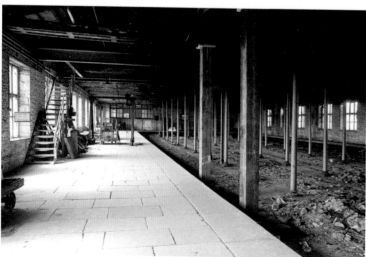

IKB's terminus building continued to receive trains as Platforms 13 and 14 up until 1965, but by the mid-1970s, when these photographs were taken, the rails had been cut off by new building across the northern end. The old station served as an additional car parking area. It was starting to look neglected and there were real concerns about its survival.

Top image: With the roof still blackened from smoke, looking northwards, the later extension to the right and the signal box piercing the wall. The central section is still at rail level with platforms on either side.

Left: Looking across the passenger shed. Originally the windows would have been unglazed to provide ventilation.

Bottom left: The one good thing about the car park days is that you could wander about at will. This is the engine shed area. Note the central iron columns and abandoned railway paraphernalia.

Side view of the original passenger shed which extends from the GWR office building, on the far left, as far as the turrets on the right of the picture. The ventilation and windows on the ridge of the roof were later additions, and as you will see on the pictures of the restored roof they have since been removed. Another addition since Brunel's time is the vehicle entrance, which is surrounded by the area of patchy stonework. In the more recent view, *below*, old meets new although the vehicle entrance still leads to a parking area under the roof of the 1870s extension. This shows up clearly here as the higher roof line extending to the right.

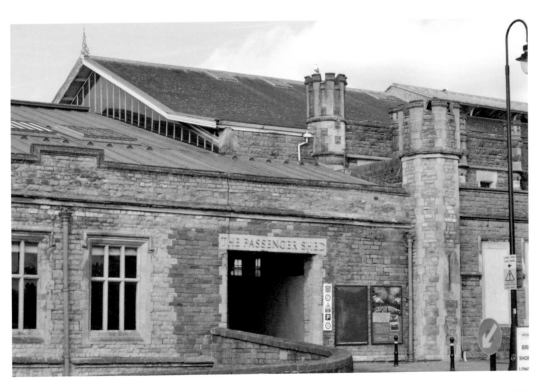

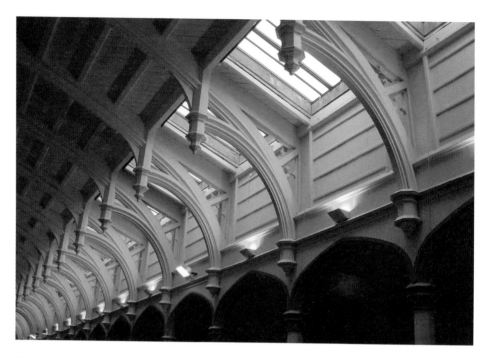

Two interior views of the passenger shed in its restored condition, with detail of the hammerhead beams. The windows/ventilation running along the ridge of the roof have been removed in keeping with the building's as-built condition. At ground level the central track area has been filled-in up to platform height. Photographed in 2006 during preparations for an event.

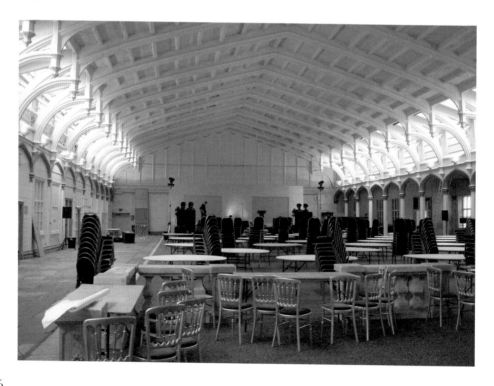

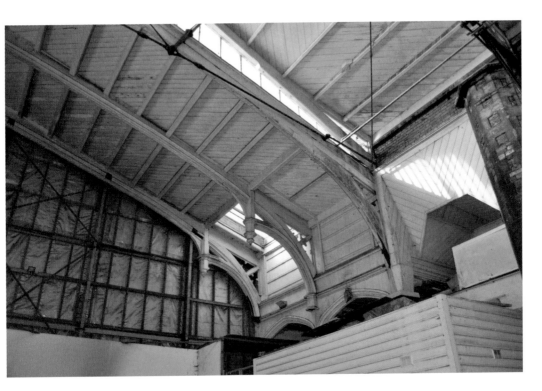

Two sections of the original roof and side arches have been left stranded on the far side of the partitioning wall and are visible from within the 1870s extension. The change in roof level where old meets new is clearly visible. The hammerheads were purely decorative as is suggested by the curved roof beam to the right of this group. *Below*: This exit leads from the platform level to the front and entrance of the new station.

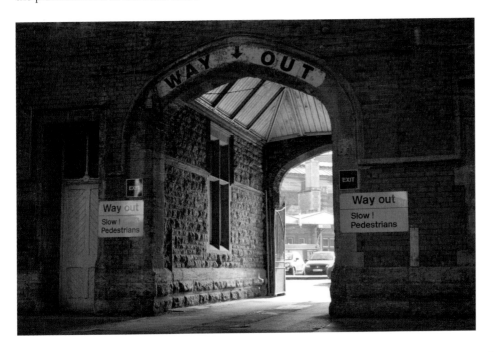

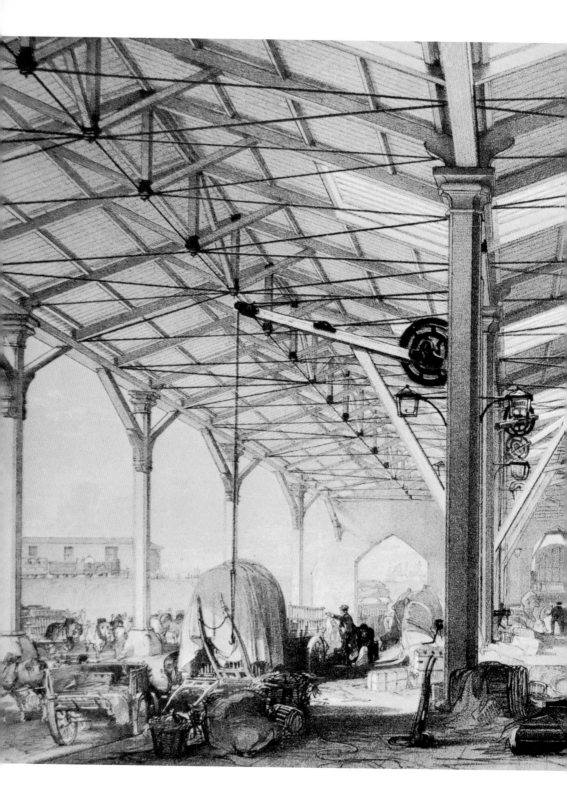

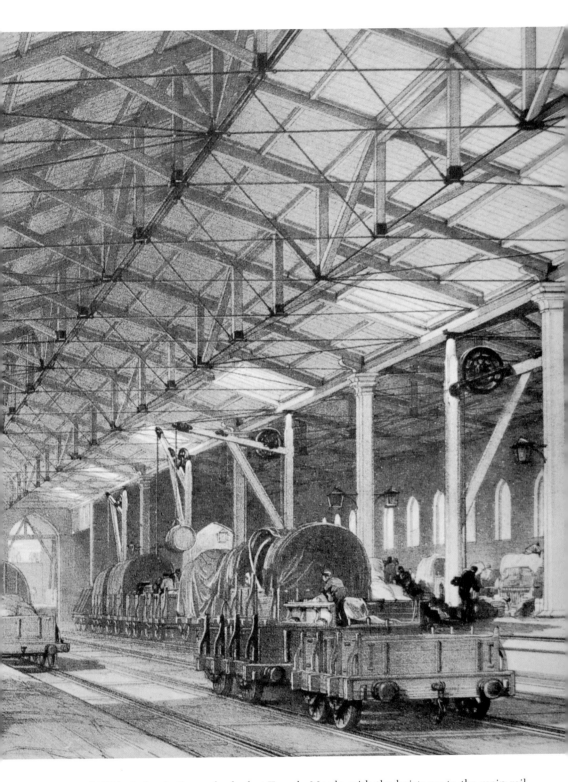

Interior of IKB's timber-built goods shed at Temple Meads, with the hoists up to the main rail level at the far end.

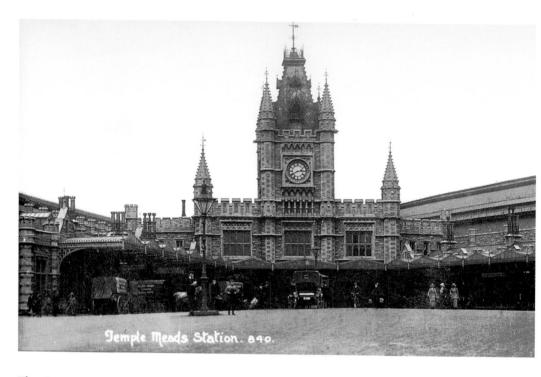

Temple Meads Station. 840.

The 1870s extension to the station featured this centrepiece, a clock tower in high-Victorian style inspired by the recently completed Palace of Westminster building in London. It might not be Brunel, in fact the identity of the architect is uncertain, but it has become the recognisable face of Temple Meads. The pointed tower was damaged by a fire-bomb in the Second World War. *Below:* The lofty space within the main passenger shed.

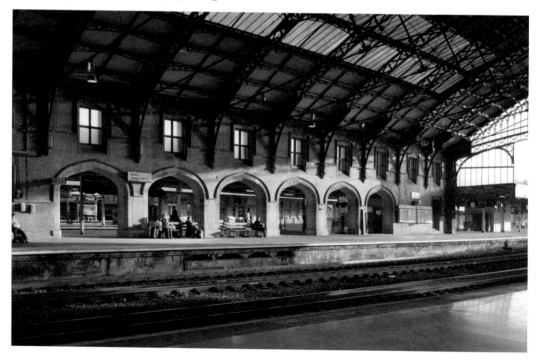

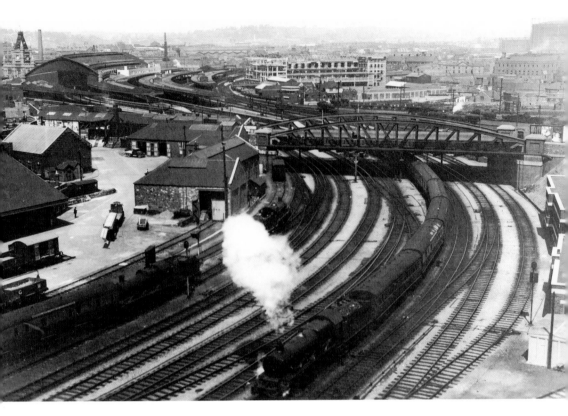

Two images of the Temple Meads site: In the upper photo, taken in the mid-1930s from Totterdown, IKB's station is off frame to the top left but you can see the later clock tower and main station roof. New construction work shows up as white buildings and, to the right, there is the new sorting office. The bridge is on the A4 Bath Road, with the goods yard to the left. (*CMcC*) *Below*: Today's view from the road bridge.

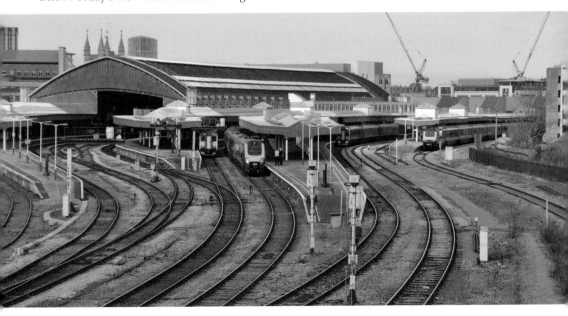

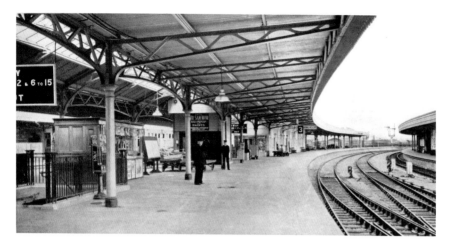

Above: Looking north on Platform 3 in 1935 with the newly-completed buildings finished in modernistic, gleaming white tiling.

old terminus continued to function, in an extended form, as Platforms 13 and 14 up until 1965. Since then the rail access has been cut off by new buildings, and by the late 1970s the old passenger shed was looking decidedly shabby in its role as a car park. Thankfully the Brunel Engineering Centre Trust stepped in to rescue the old building which has now been restored and serves as an occasional venue for a variety of events. This part of the building isn't generally accessible to the public, but the extension is still a parking area and sections of the Brunel roof are visible from that side of the partition wall. In the 1990s the engine shed was incorporated within the Empire & Commonwealth Museum, but that has now gone. There are suggestions that the Brunel building might be returned to railway use sometime in the future.

Brunel's Goods Shed

In addition to the station, Temple Meads was also the site of a timber goods shed designed by Brunel. This was built at a right-angle to the main station building, on the land which extends to the Floating Harbour for the easy transfer of goods between the railway and barges. The goods shed was open on one side and featured a fine timber roof tied with iron rods. As it was on a slightly lower level than the main station the railway wagons had to be raised or lowered by hoists. Bourne provides the following description:

> This is a rectangular structure, 326 feet by 138 feet, divided by two lines of rails; the sides are intended for ordinary carts and wagons. From the platforms rise the columns that support the roof, and between each column is a crane, sweeping both over the railway truck within and the cart upon its outer side. Goods are thus transferred to and from the railway trucks. In the centre are three turntables, each 32 feet diameter, capable of turning a full

sized wagon, and a rolling platform connecting all the lines of rail with each other. The weigh-bridge and office are at the north and the other offices are at the south end, on either side of the shed.

In the 1870s the goods shed was demolished as part of the rebuilding and expansion of the station.

Departing from Bristol

As the main Bristol to London line winds outwards to the south-east towards Bath, it passes over the River Avon on a hidden Brunel bridge. This Grade I masonry structure has a wide central arch and two smaller flanking arches in the familiar Gothic style. Unfortunately it is hard to see nowadays as it has been hemmed in on both sides by later steel girder bridges carrying additional lines, and the immediate area has been built on. But you can see it at a distance from the Feeder Road bridge.

Continuing its course along the river valley the railway passes through several tunnels. These are hard to get close to but Bourne was much taken by them and his lithograph of Conham Wood Tunnel, known as No. 2 Tunnel, for example, reveals a romanticised castle ruin. In truth Brunel had made the best of a landslip on one side to produce this picturesque look.

The first station is Keynsham, a little under five miles from Temple Meads. It opened on 31 August 1840 and was renamed Keynsham and Somerdale in 1925

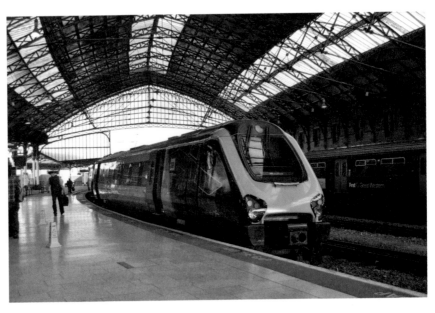

Cross Country train at Temple Meads, February 2013.

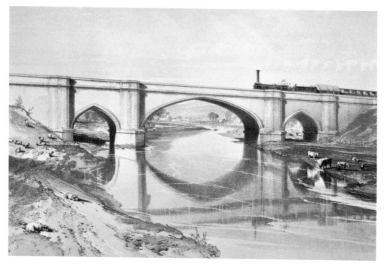

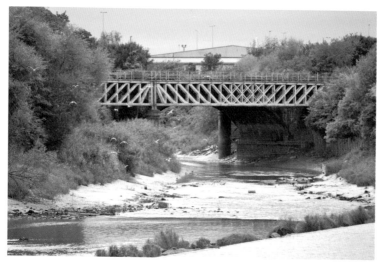

Top and middle left:
This is how Brunel's railway bridge over the Avon, on the approach into Temple Meads, looked to J. C. Bourne in 1846. Today the bridge is still there, but it is concealed and protected by later steel girder bridges carrying extra track on either side. This is the view from the Feeder Road bridge. You can't get much closer as the surrounding area is covered by industrial and commercial buildings.

Bottom left:
A highly romanticised view of Tunnel No. 2, otherise known as the Conham Wood tunnel. The landslip on the left-hand side was incorporated into the semi ruinous theme.

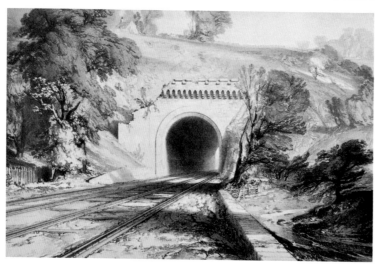

with the opening of the Fry's chocolate factory at Somerdale. The station was rebuilt in 1931, reverted to the Keynsham name in 1974, and was rebuilt for a second time in 1985. Today it is served by First Great Western trains.

The final feature on the line before it approaches the outskirts of Bath, and one that is at the limit the area covered by this book, is the 500 foot long tunnel at Saltford which features fine flat-topped Gothic-arched portals.

Explore Temple Meads and the Bristol to London Line

• Big railway stations are always busy, always fascinating. Temple Meads is located on the A4 Temple Gate road. Brunel's original terminus for the GWR is on the left-hand side of the approach road, and the main part of the station, the 1870s extension, is entered beneath the clock tower. Note the B&ER headquarters building on the right-hand side.
• There is an excellent view of Temple Meads from the A4 Bath Road bridge, just to the west of the station. (OS map 172, grid ref ST 598721).
• The bridge over the Avon is hard to see close-up (OS map 172, grid ref ST 614724). Best view is from the Feeder Road bridge.

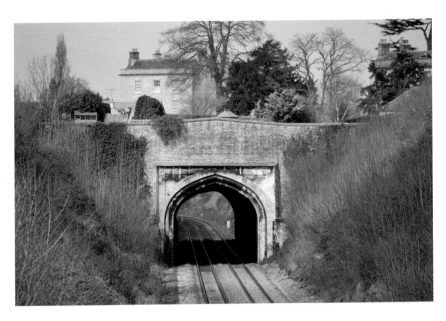

Typically Brunellian tunnel portal at Saltford.

In many respects the *Great Western* followed conventional lines for a wooden-hulled paddle ship, but at 212 feet she was exceptionally large for the times. She had to be in order to carry a sufficient supply of coal. Brunel understood that a bigger ship was far more efficient and presented the only means of crossing the Atlantic by steam. *Below:* A scene from early 1837 with the *Great Western* nearing completion to the far right. Patterson's shipyard was on the south side of the present Prince Street bridge. St Mary Redcliffe can be seen beyond, and the square building on the far left is the Bush warehouse, now home to the Arnolfini art gallery. Note the un-built nature of the harbour side.

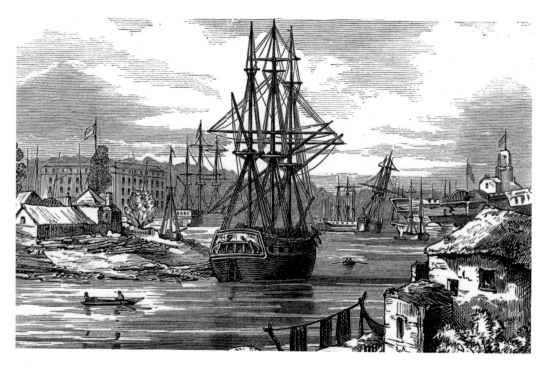

Transatlantic Connections

On one of the houses in a smart street near Brandon Hill, there is a commemorative plaque, not to Brunel but to Thomas Richard Guppy (1798 –1882) 'Engineer, friend and backer of I. K. Brunel'. In Bristol it was Brunel's network of friends, garnered from the Clifton project and the GWR, who formed the bedrock, the launchpad if you like, for his meteoric rise as the region's pre-eminent engineer. It was Guppy who had been the driving force behind the Great Western Railway, and such was his faith in the young engineer that even before the first trains had run between London and Bristol he was ready to back yet another of Brunel's audacious schemes. At a meeting of the directors of the GWR, held in Blackfriars in 1835, one of them happened to comment on the inordinate length of the line. They had meant it as a criticism. But in response Brunel casually exhaled a curl of bluish smoke and suggested, 'Why not make it longer, and have a steamboat go from Bristol to New York and call it the *Great Western*?' And, apocryphal story or not, that is just what they did.

In January 1836 the Great Western Steamship Company (GWSC) was formed. It wasn't part of the GWR as such, but the directors did include Brunel's closest friends; Guppy of course, and Peter Maze – also of the GWR – plus a retired naval officer called Captain Christopher Claxton who had been Quay Warden when Brunel was appointed to make improvements to Bristol docks in 1833 – *see page 55*. Brunel would act as engineer to the new company and he gave his services for free. (Brunel made a good enough living as an engineer, but he did not become as wealthy as some of his contemporaries thanks primarily to his tendency to work without a fee and to invest his own money in his projects

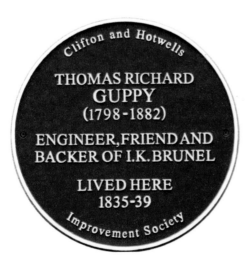

Thomas Richard Guppy was an important figure in Brunel's circle of Bristollian contacts. He was instrumental in the formation of both the GWR and the Great Western Steamship Company, and it was Guppy who introduced IKB to the Docks Company. The plaque is in Berkeley Square.

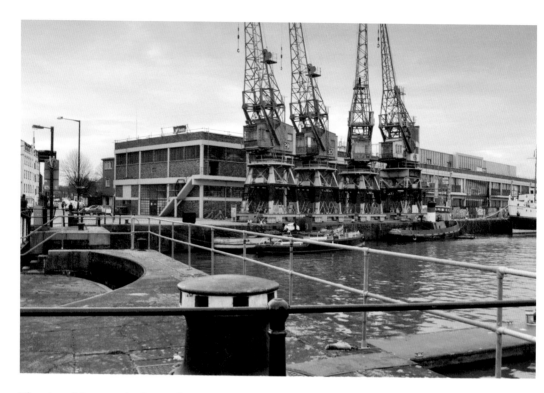

The site of Patterson's shipyard is now occupied by these former dock buildings on the south end of the Prince Street bridge. To the right of the photo the new Bristol Museum is under construction, although sadly this features very little about IKB and his work. *Below*: The commemorative plaque on the wall of the dock building.

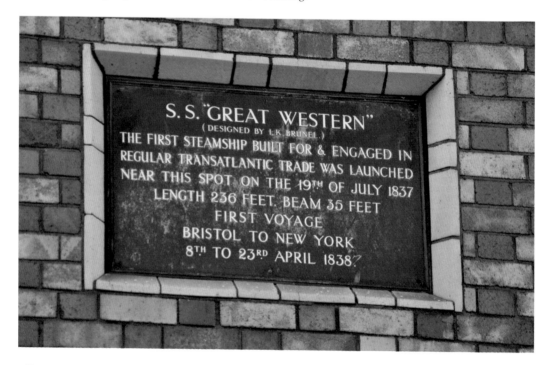

S. S. "GREAT WESTERN"
(DESIGNED BY I.K. BRUNEL)
THE FIRST STEAMSHIP BUILT FOR & ENGAGED IN
REGULAR TRANSATLANTIC TRADE WAS LAUNCHED
NEAR THIS SPOT ON THE 19TH OF JULY 1837
LENGTH 236 FEET. BEAM 35 FEET
FIRST VOYAGE
BRISTOL TO NEW YORK
8TH TO 23RD APRIL 1838.

In most respects the company's first ship, the timber-hulled *Great Western*, followed conventional lines, although at 212 feet (65m) in length and with a displacement of 2,300 tons she was considerably bigger than any other ship afloat. Bristol ship-builder William Patterson was selected to build the *Great Western* at his yard near the Prince Street bridge, and in June 1836 the keel was laid. Because of her length great emphasis was placed on longitudinal strength and extra stiffening was provided by the insertion of iron diagonals and a row of iron bolts running the full extent of the hull. The *Great Western* was driven by a pair of paddle wheels, assisted by sail as was the convention with the early steamships. However, there were many nay sayers who thought that the notion of a transatlantic steamship was pure folly and argued that a vessel could not possibly carry enough fuel for such a voyage. Enter Dr Dionysius Lardner, an outspoken critic who targeted Brunel at every opportunity:

As to the project of making the voyage directly from New York to Liverpool, it was perfectly chimerical, and they might as well talk of making the voyage from New York to the Moon... 2,080 miles [3,347 km] is the longest run a steamer could encounter – at the end of that distance she would require a relay of coals.

But what Dr Lardner failed to grasp was a rudimentary factor in the design of large ships. The bigger they are the better they are, as Brunel pointed out:

The resistance of vessels does not increase in direct proportion to their tonnage. This is easily explained; the tonnage increases as the cubes of their dimensions, while the resistance increases about as their squares; so that a vessel of double the tonnage of another, capable of containing an engine of twice the power, does not really meet with double the resistance. Speed therefore will be greater with the large vessel, or the proportionate power of the engine and consumption of fuel may be reduced.

The *Great Western* was launched on the morning of 19 July 1837 cheered on by a crowd 50,000 strong. With her large paddle wheels carried on the upper deck she sailed to the Thames for final fitting out and was escorted on the journey by the steamship *Benledi*. In the meanwhile, back in Bristol the Royal Western Hotel was being built to accommodate passengers who would travel down by train from Paddington to catch the steamship to New York. Located in St George's Street, just behind the present council house, it was designed by the architect R. S. Pope in collaboration with Brunel. It is a fine building with an imposing façade of columns rising to the height of the first two storeys. As with Temple Meads there were arches on both sides for horse-drawn carriages to enter and exit.

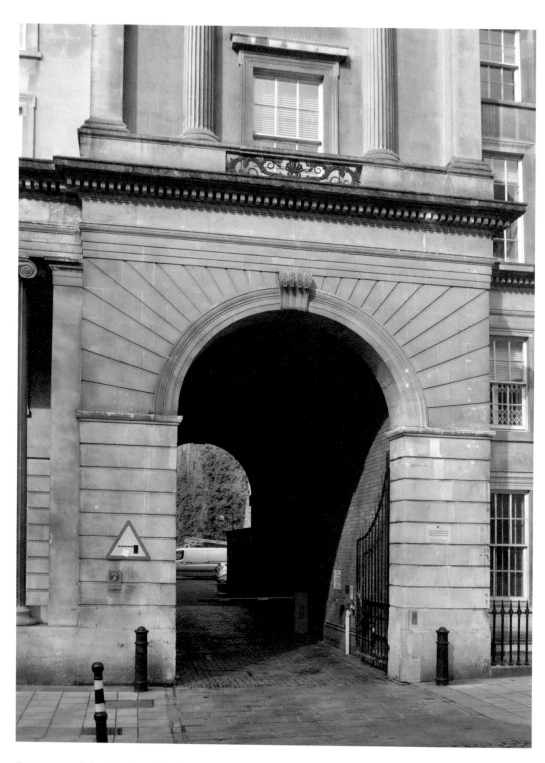

Entrance arch leading into the former Royal Western Hotel which was built to accommodate travellers who had come down from London by train before they caught the transatlantic steamship to New York.

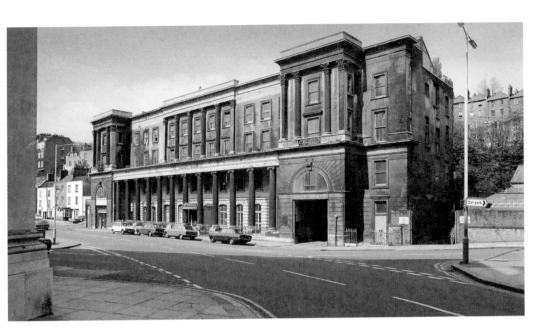

Above: Photographed in the 1970s, the former Royal Western Hotel building in St Georges St, behind the Council House. It is an elegant building designed by the architect R. S. Pope in collaboration with Brunel. IKB's vision of a through connection to New York via steamship was scuppered by the Docks Company's inability to improve Bristol's facilities to handle larger ships and by the grounding of the *Great Britain* in 1846. The building served as a Turkish baths at one time, and is now used as offices.

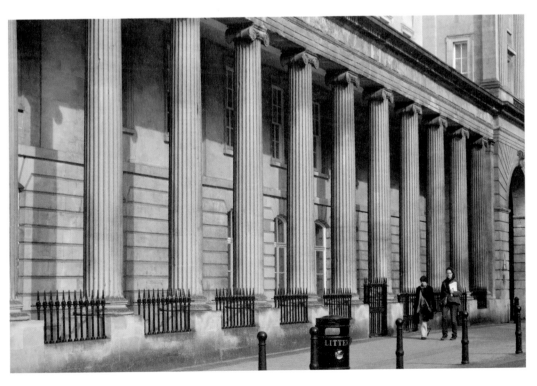

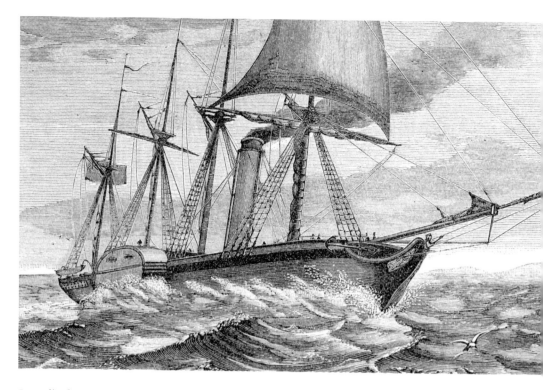

Brunel's first ship, the *Great Western*, demonstrated the viability of a transatlantic steamship service.

The first advertisements for transatlantic sailings appeared in March 1838 announcing that the 128 state rooms were all of one class with a fare of thirty-five guineas, with twenty 'good bed places' allocated for servants who travelled at half price. That same month the *Great Western* was put through her first steam trials, but not without incident. Lagging on the boilers caught fire and Brunel fell through a charred ladder into the boiler room, his fall saved by Captain Claxton. The ship returned to Bristol, but significantly not to the city docks as the entrance lock was too narrow now that her paddle wheels were in place, and alternative moorings were arranged at Pill on the River Avon.

In April 1838 the *Great Western* set off for New York on her maiden transatlantic voyage. Irritatingly for Brunel the *Great Western* wasn't the first steamship to make the Atlantic crossing as she had been pipped to the post by the smaller *Sirius* which had sailed from Liverpool several days earlier. In the event the crew of the *Sirius* had resorted to burning furniture to keep the boilers going, and it was the *Great Western* that demonstrated that a regular transatlantic service by steamship was possible. Unfortunately Bristol was soon out of the picture as the Bristol Dock Company had failed to heed IKB's calls for improvements to the entrance locks and the ship operated from Liverpool.

Undeterred the GWSC started work on a second vessel, a revolutionary ship of iron which eventually became the *Great Britain*.

Explore the Great Western steamship

• There is no ship to see. The only indication of Patterson's shipyard is a plaque on a dock building at Princes Wharf, off Wapping Road. Some items, including the *Great Western's* bell, are displayed at the *Great Britain* museum.
• The former Royal Western Hotel is in St George's Road, behind the council house. It ceased to be a hotel in 1855, and after a stint as a Turkish baths it is now used as council offices.
• The plaque to Thomas Guppy is at No. 8 Berkeley Square.

A rare view of the *Great Western*, in the dry dock to the left, during her time with the West India Mail Steam Packet Company – *see page 49*. The image was published in *The Illustrated London News* in May 1851 to show the launch of the company's *Orinoco* steamship, in the centre, at Northfleet. *(CMcC)*

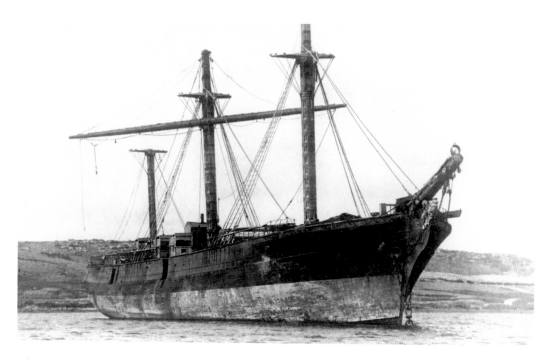

Lying forlorn, the *Great Britain* was abandoned at Sparrow Cove in the 1930s after a long and varied career. *(CMcC)* Built as a transatlantic liner she was refitted for the 12,000 mile run to Australia, and when she became too old for that her engines were removed and she was converted to a windjammer. This beautiful iron ship was built in the Great Western Dock in Bristol and launched on 19 July 1843. She returned to the same dock exactly 137 years later to the day.

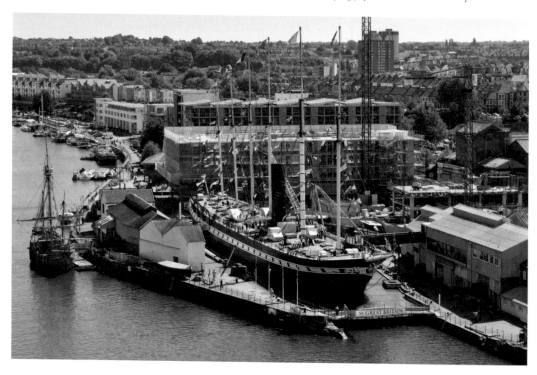

A Ship of Iron

Brunel had planned a second wooden-hulled paddle-driven ship to follow in the wake of the *Great Western's* transatlantic successes. The African oak had been purchased, and a new dry dock – the Great Western Dock, named after the company not the previous ship – was prepared and it included space on either side for the paddle boxes. The ship even had a name; *The City of New York*. Brunel was aware that wrought iron would be both cheaper and stronger than wood, but its use for an ocean-going vessel was restricted because the iron would throw out a ship's compass. This problem was overcome by a system of correcting magnets devised by the Astronomer Royal, and when the iron-hulled paddle steamer *Rainbow* arrived in Bristol in 1838, equipped with the new apparatus, Brunel readily swapped to iron for the new ship.

The next piece of the jigsaw fell into place the following year when the *Archimedes* came to Bristol. This experimental vessel was driven by a screw propeller devised by Francis Pettit Smith. In his customary fashion Brunel brought the two elements together to create the first ocean-going iron-hulled ship with screw propulsion. It was a combination that defined the shape of modern shipping.

On 19 July 1843, six years to the day after the launch of the *Great Western*, thousands of Bristolians flocked to Brandon Hill and the dockside to witness her launch. She looked magnificent; 322 feet (98 metres) long with six tall masts named after the days of the week. The guest of honour was Prince Albert who had travelled down from London by special train driven by Daniel Gooch who was accompanied on the footplate by Brunel. At the appointed moment Mrs Miles, the wife of one of the GWSC's directors, stepped forward to name the ship as the *Great Britain*. When she swung the bottle of champagne it missed its mark, at which point the Prince stepped forward, grabbed another bottle and hurled it against the iron bows, showering champagne and fragments of glass on the workmen below.

The ship remained in the Floating Harbour until late the following year while being fitted out and made ready for the sea trials. The first attempt to get her through the Cumberland Basin and out to the river took place on 10 December 1844, but she became stuck as the docks company had not widened the locks as expected, and also because she was riding slightly lower in the water owing to the heavier steam engines which had been installed. Some dockside masonry had been removed, but its wasn't enough and if it wasn't for the quick action of Captain Claxton, who was in the tug at the rear and decided to pull the *Great Britain* back before the tide ebbed, she could have been left high and dry with every likelihood of being badly damaged. Brunel immediately put men to work removing more of the dockside masonry and at the high tide that night they made a second attempt. Once again thousands of people flocked to the docks

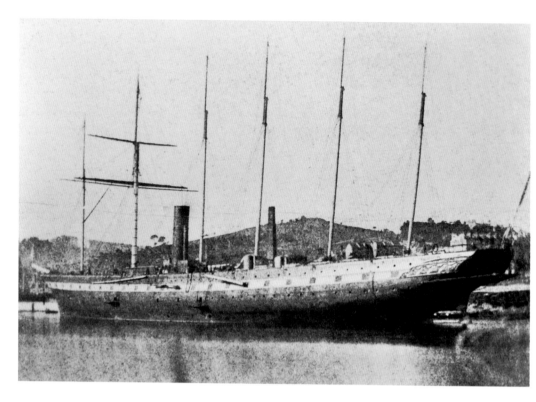

Said to be the earliest photograph of a ship. Taken by the pioneering photographer W. H. Fox Talbot, it shows the *Great Britain* beside the Gas Ferry Wharf during final fitting and prior to her departure from Bristol's Floating Harbour. The scene on the night of 10 December 1844 as the *Great Britain*, illuminated by light from barrels of burning tar, was finally 'released from her long imprisonment, in Cumberland Basin, Bristol' – as *The Illustrated London News* put it. On the first attempt the ship had almost become stuck in the entrance lock and was only saved by the quick thing of Captain Claxton who had her pulled back into the basin before the high tide receded. Additional masonry was removed from the dock walls before the second attempt, shown *below*.

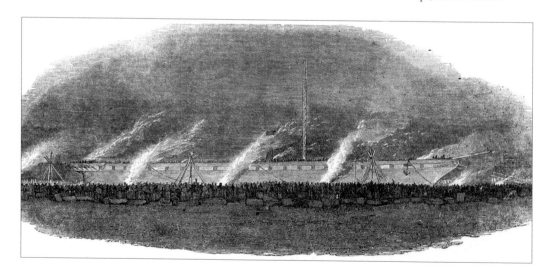

The spacious promenade deck of the *Great Britain*. 'The cabins are superb. The principal saloon is 110 ft long, the fore saloon is 65 ft, and both are upwards of 8 ft high,' wrote one contemporary observer. 'In a word, the character of the ship is sunk in the beauties and lordly air of a noble mansion.'

as the ship edged forward. According to *The Illustrated London News* Captain Hoskin was 'obliged to make a dash at the lock'. This account comes from the *Bristol Mirror*:

> We cannot attempt to describe in appropriate language the splendid appearance of the *Great Britain* as she entered the lock, and passed as it were through the crowds of people assembled for the occasion. On either side of the lock blazed barrels of tar, with very short intervals between them, to the distance of more than 200 yards, the illumination from which, on the giant ship, the water, and the faces of the multitude is not to be described. She passed through at a rapid pace, touching nothing but the rail of one of the bridges, which was hooked by anchor and carried away like a thread. She was moored by the side of the wing wall outside the lock for the night, to be ready for her passage down in the morning.

With Captain Claxton in charge of the tugs the ship moved off down the river in the early morning to the cheers of crowds who gathered on the river banks. Moving easily in the water she passed under the forlorn towers of the unfinished Clifton Suspension Bridge, never expecting to return to Bristol, and was moored at Kingsroad while her own engines were made ready. At around noon the *Great Britain* was moving under her own power.

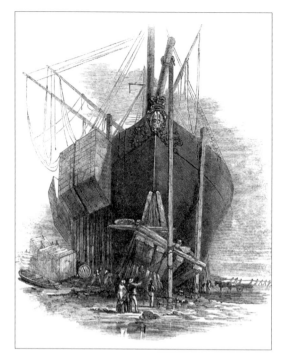 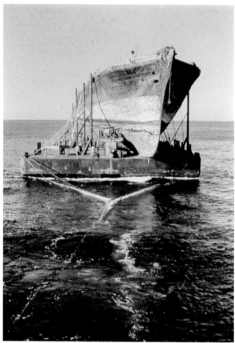

Left: Disaster struck in September 1846 when the *Great Britain* ran aground at Dundrum Bay on the Irish coast. Captain Hoskins blamed a new lighthouse on the Isle of Man for his error, but it may be that the ship's iron hull had caused the compass to misread. *Right:* No longer seaworthy the *Great Britain* riding atop the pontoon on which she was finally towed back to Britain in 1970.

Transatlantic liner

The *Great Britain* made her first transatlantic run from Liverpool to New York in 1845, sailing with just fifty passengers on board as there were widespread concerns about the method of construction and the effect that the iron hull might have upon the compass. Brunel thought the latter problem had been solved by a system of correcting magnets devised by the Astronomer Royal. Passenger confidence gradually picked up and by the fifth voyage, in September 1846, she sailed with 180 passengers. Unfortunately in the darkness and driving rain the ship ran aground at Dundrum Bay, on the Irish coast in County Down. Captain Hoskin claimed he had been confused by a newly commissioned lighthouse on the southern tip of the Isle of Man, but it is quite plausible that the compass was to blame. Thankfully there was little damage to the hull and Brunel devised protection for the vulnerable vessel until she could be re-floated the following summer.

The *Great Britain* was saved, but the GWSC could not survive the financial repercussions of this incident and both ships had to be sold. The *Great Western* was purchased by the West India Mail Steam Packet Company in 1847 and used on the West Indies route. She also served briefly as a troopship during the Crimean War, as did the *Great Britain*. In 1857 the *Great Western* was broken up at Castles' Yard in Millbank, not far from where Brunel's final ship, the *Great Eastern*, was being built. It is said that the engineer went to Millbank to take a farewell look at the old ship.

The *Great Britain* was sold in 1850 for a fraction of her original cost. Bought by Gibbs, Bright & Co. of Liverpool, she was refitted for the 12,000 mile run to Australia where the discovery of gold was attracting immigrants by the thousands. To reduce the requirement for coal on the long voyage she became a sailing ship principally with a capability to steam if required. The number of masts was reduced to four, although with an increased sail area, and twin

On 19 July 1970 the *Great Britain* returned to Bristol, riding the spring tide for the final part of her journey to the Great Western Dock. Thousands of onlookers gathered around the Avon Gorge to capture the moment when Brunel's iron ship passed under the Clifton Suspension Bridge for the first and only time.

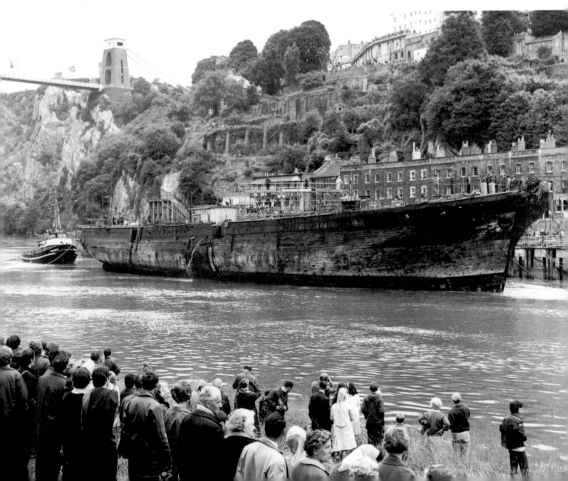

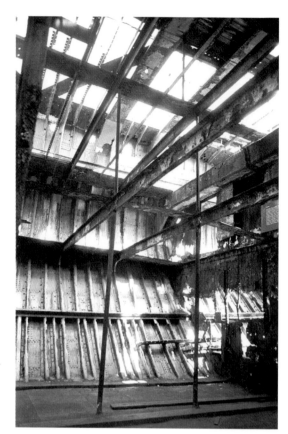

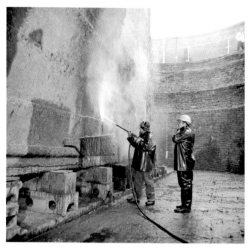

Once back in dry dock the ship was stripped down to her bare bones, with all woodwork removed, ready for treatment to the ironwork as part of her long restoration programme. These photographs from the mid-1970s show that the girders were generally in good order although there was little doubt that the ship would not have survived the Atlantic batterings at Sparrow Cove for much longer.

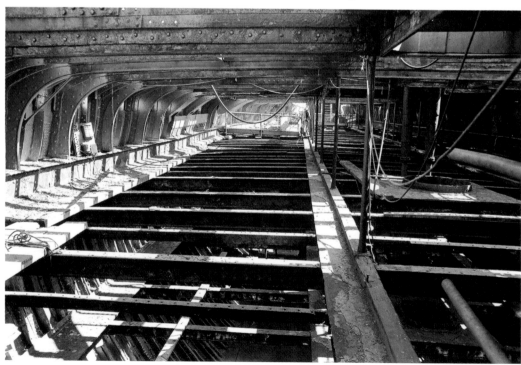

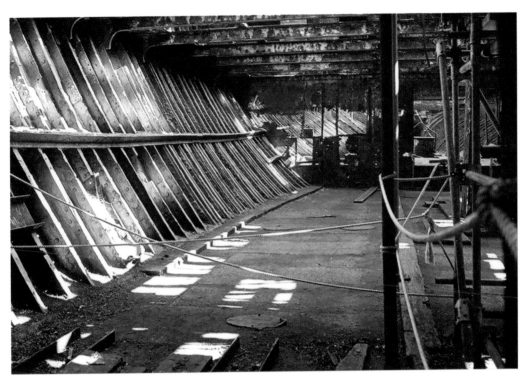

Above: The lower deck looking forward. It was a great opportunity to see the structure of the ship and visitors had access to some sections of the hull as it was important to keep the money coming in.

funnels were installed for a new two-cylinder oscillating engine. Passenger accommodation was increased to 700 by the addition of an extra upper deck and the conversion of the saloon deck to provide further berths.

Between 1852 and 1875 the *Great Britain* made thirty-two voyages to Australia, with a ten month gap in 1854 during her Crimean service. When she was too old for the Australian run the engines were removed and she was converted into a cargo-carrying windjammer in 1882. Her sailing days came to an end in 1886 after she ran into difficulties rounding Cape Horn. Her captain sought refuge in Port Stanley on the Falkland Islands, but it was too expensive to repair the ship and she was sold for £2,000 to serve as a floating store for wool and, later on, for coal. In the 1930s she was deliberately beached at Sparrow Cove and abandoned.

In 1967 a naval architect, Dr Ewan Corlett, wrote to *The Times* urging that the rusting hulk should be recovered or, at the very least, fully documented. A survey revealed that she was actually in good shape, despite a 13 inch crack caused by the constant action of the sea, and when the businessman Jack Hayward came forward with funding a rescue operation was mounted. As the ship was no longer sea-worthy a direct tow was out of the question and the Hamburg salvage company of Ulrich Harms devised a submersible pontoon to

carry her back in 1970. Upon arrival at Avonmouth the pontoon was removed and on 19 July – the anniversary of her launch – Brunel's iron ship rode on the spring tide back to Bristol and the Great Western Dock where she had been built.

<div style="border:1px solid">

Explore the Great Britain

• The ship has been lovingly restored at the Great Western Dock where she was originally built. The dockside buildings house an exhibition with many artefacts including some from the *Great Western* and the *Great Eastern*. A glass ceiling keeps the hull dry in a controlled environment in order to halt the rusting progress after so many years standing in salt water. The dock is on Gas Ferry Road, accessed by car via Cumberland Road, or you can walk along the dockside.

</div>

More images from the early stages of restoration, showing the replica skylight for the promenade deck and work being carried out on the bow. Great emphasis was placed on adding elements that added to the visitor's understanding of the ship and showed tangible evidence of the progress being made. *Opposite*: Display panels photographed near the Cumberland Basin in 2013.

THE CELEBRATED AUXILIARY STEAM-SHIP

GREAT BRITAIN,

3209 Tons, and 500 Horse-power,

CHARLES CHAPMAN, Commander,

IS APPOINTED TO LEAVE THE RIVER MERSEY,

FOR MELBOURNE AND BRISBANE

(Landing Passengers and Cargo at Melbourne, and proceeding without delay);

TAKING PASSENGERS ALSO FOR

SYDNEY, ADELAIDE, AND NEW ZEALAND,

ON SATURDAY THE 25th OCTOBER, 1873.

This magnificent and far-famed Ship has made the passage out to Melbourne in the unprecedented short time of 53 days. She affords an opportunity for Passengers to reach Australia in almost as short a time as by the Overland Route, via Southampton, without incurring the very heavy expenses attendant thereon, and avoiding entirely the discomfort of frequent changes. Her Saloon arrangements are perfect, and combine every possible convenience, Ladies' Boudoir, Baths, etc.; and her noble passenger decks, lighted at intervals by sideports, afford unrivalled accommodation for all classes.

FARES,

Including Steward's Fees, the attendance of an experienced Surgeon, and all Provisions of the best quality.

	TO MELBOURNE.		TO BRISBANE.	
AFTER SALOON {POOP	60 and 70 Guineas		66 and 76 Guineas	
BELOW	55	60	61	66
SECOND CLASS (on Deck)	25	30	28	33
THIRD CLASS	25		31	33
STEERAGE				

Children under Twelve Years, Half-price.

A STOLEN HORSE.

A Man who calls himself HARRY POTTEE (supposed to be a feigned name) has been detained in the Parish of Tidenham, in the County of Gloucester, with a dark brown CART GELDING, which he had in his possession under very suspicious circumstances.

The man is about five feet seven inches in height, with a small mark on the right cheek, and sandy whiskers, says he is a labourer, born at Frome, in Somersetshire, and has been residing lately at Bath; had on when apprehended a dark coat, dark striped waistcoat, and light kersemere pantaloons, with Wellington boots.

The Horse is rising six years old, has three of his legs entirely black; around the near leg behind there is a little white below the fetlock joint; has a small star in his forehead, some small scars on his neck from galls of the collar, and a few gray hairs in the part of the mane where the collar has rubbed; he is between 15 and 16 hands high, and is an active useful kind of Cart Horse; his tail has the appearance of having been disfigured by being cut with a knife.

The Man is committed to Little Dean Gaol for further Examination on Wednesday next.

Further particulars may be known, and the Horse seen, at the George Inn, Stroat, in the said parish of Tidenham; and by applying to Mr. LUCAS, Solicitor, Newnham, Gloucestershire.

TIDENHAM, Nov. 10th, 1831.

J. Clark, Printer, Back Square, Gloucester; where Orders and Advertisements for "The Horse" are received.

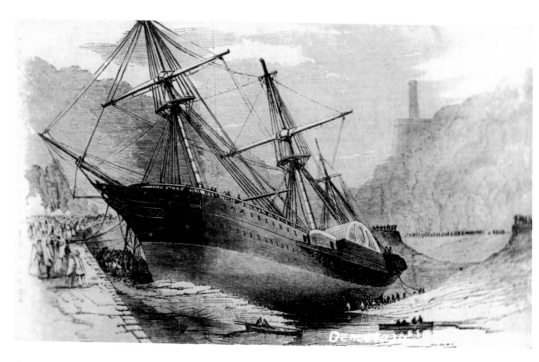

On 10 November 1851 the steam packet *Demerara* was caught out by the River Avon's treacherous tides. Built for the West India Steamship Company by Willam Patterson in Bristol, she was second only to the *Great Britain* in terms of size. At great cost to Patterson the *Demerara* was re-floated and taken back to the dock for repairs. Note the Leigh Wood tower of the unfinished Clifton bridge in the background. *(CMcC) Below:* The view from the Clifton bridge, with the north entrance lock to the left, Brunel's lock in the middle, and the river curving round into the New Cut on the right.

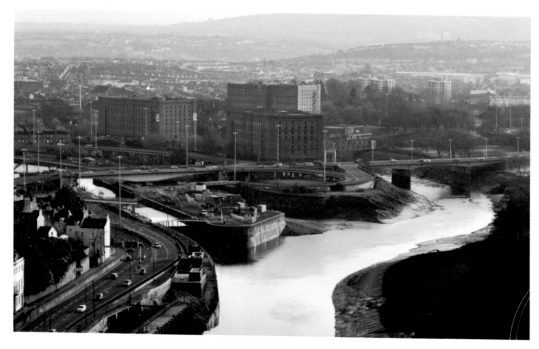

Docks and Other Works

By the beginning of nineteenth century the merchants of Bristol had grown wealthy on the trade that passed through the city's docks; mostly tobacco, timber, sugar, and cotton, but also the appalling 'Africa trade'. Yet despite this the port, which had been second only to London in 1700, was in decline and had slipped to ninth place with other regional ports in ascendancy. The problem lay with the tidal waters of the River Avon. Bristol is eight miles from the sea and vessels had to negotiate the winding course of the river and the twice-daily tides that extended into the docks themselves and threatened to leave them stranded high and dry. It is from this that we have the expression 'ship-shape and Bristol fashion' as a ship's hull had to be well-built if it was not to have its back broken on Bristol's treacherous mud-banks.

Clearly something had to be done and in 1804 work began on creating William Jessop's Floating Harbour, or 'Float' as it is sometimes known. Jessop's scheme involved enclosing the river between the Neetham Dam, at Temple Meads, and the Rownham Dam on the western side of the city, thus keeping the docks permanently full of water. To accommodate vessels either entering or leaving the docks, the Cumberland Basin was created as a parking area between the two. Vessels would navigate the river at high tide, as before, but now they could pass through a lock to the safety of the basin. Outgoing vessels departing from the docks could wait in the basin for the next high tide for them to proceed down the river. To cope with the coming and going of the tidal waters the New Cut was created and this skirted around the south side of the docks.

Jessop's Floating Harbour gave Bristol a much needed lease on life, but it did bring problems of its own. The River Frome fed fresh water into the docks, keeping up the levels, but the rate of flow was insufficient to wash the mud particles away which resulted in the clogging up of the harbour. To tackle this, a stop gate was installed at the Prince Street bridge in order to isolate one half of the harbour at a time so that the mud could be cleared in that section. But the periodic closing of half the harbour was unpopular with ship owners and dock companies. Something better was needed and Brunel's circle of influential friends introduced him to the Dock Company which, in 1832, commissioned him to inspect the docks and report back to them with his suggestions. Obviously the solution was to improve the flow of water through the Floating Harbour and Brunel proposed raising the height of the Neetham Dam and installing gates at the Rownham Dam on the western side of the harbour to ensure that the mud was carried out into the Cut. These measures would convert the 'overfall' dam, which acted much like the overflow on a bath, into an 'underfall' which was more like a plug hole. Brunel also designed a small scraper boat to be winched backwards and forwards across the harbour to shift the accumulated mud, by means of a submerged blade or scraper, towards the entrance of the Cumberland Basin, where the tidal waters would carry the mud away.

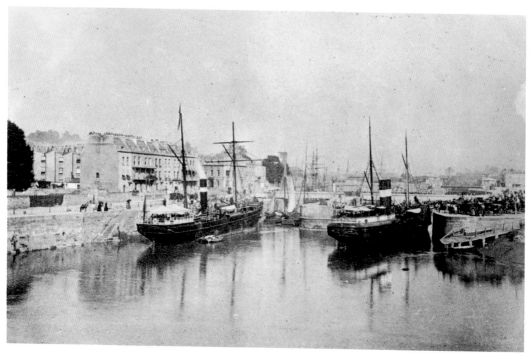

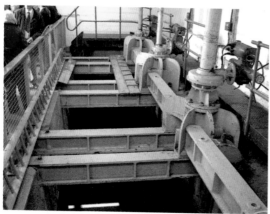

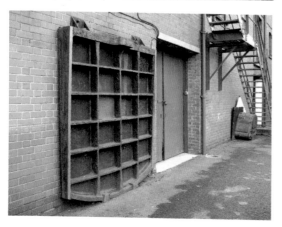

Above: Cumberland Basin in 1866, with two vessels of the Bristol Steam Navigation Company. The Cumberland basin is a massive parking area for ships awaiting the tide. *(CMcC)*

Left: The deep pools at the Underfall Yard where the sluice gates leading out to the New Cut are located, plus one of the old gates on display at the Yard. It was Brunel who turned the weir at this location into a system of underfall sluices. When the deep sluice is opened a powerful undercurrent sucks the silt out of the Floating Harbour. Restored in the 1990s the Underfall Yard is now a Scheduled Monument under the care of the Underfall Restoration Trust.

Completed in 1834, his steam-powered dredger worked well and when the first one was worn out a second dredger, designated BD6 for Bristol Docks, was built to the same design and this continued in operation until 1961. Its engine and mud paddle are now held by the city's museum. A similar drag boat was built to Brunel's design to carry out a similar job at Bridgwater and this boat is now at the maritime museum in Eyemouth, Scotland.

Brunel South Entrance Lock and bridge

In 1835 Brunel had warned Bristol's Dock Company that the existing 33 ft-wide South Entrance Lock between the river and the Cumberland Basin was too narrow. Unwilling to spend money they responded by making only minor improvements in 1845, further exacerbating Bristol's decline as a great sea port. Brunel's new South Entrance Lock was eventually completed in 1849. It measured 262 ft by 54 ft and featured a semi-elliptical bottom for maximum clearance of laden vessels. To seal the lock he devised a system of iron 'casson' gates which were divided into three chambers, one of which contained a pocket of air to create partial buoyancy in high water. They were moved on iron rails via a manually operated capstan, hinging sideways into recesses within the side of the lock. To allow road traffic to pass over the lock Brunel devised a swing bridge which featured innovative tubular

Built in Bristol in 1844 by G. Lunnel & Co., to a design by IKB, the scraper boat *Bertha* operated in Bridgwater docks. A close relative to the boats designed by Brunel to clear silt from Bristol's Floating Harbour, *Bertha* now resides at the World of Boats Museum in Eyemouth, Scotland. *(Dick Warren)*

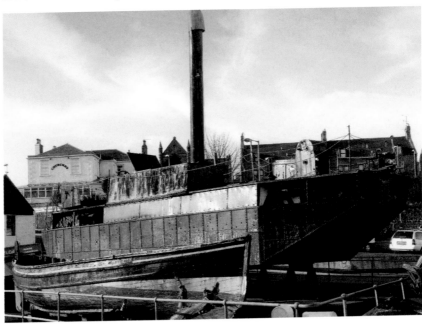

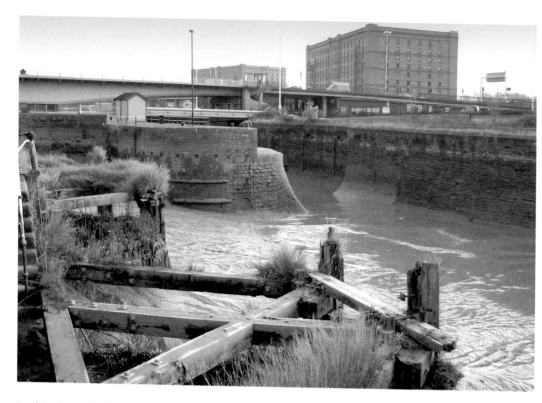

Looking towards the entrance locks into the Cumberland Basin, with the North Entrance Lock on the left and Brunel's South Entrance Lock on the right. At low tide it is possible to see the curved bottom of IKB's lock. *Below*: Another view of the South Entrance Lock.

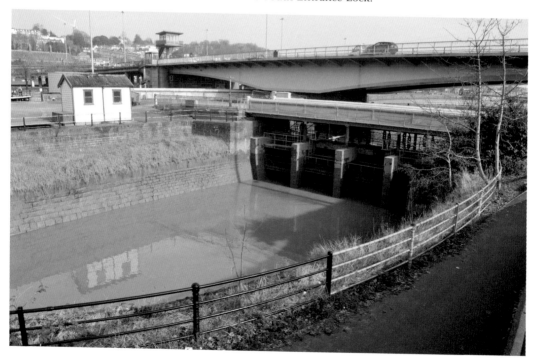

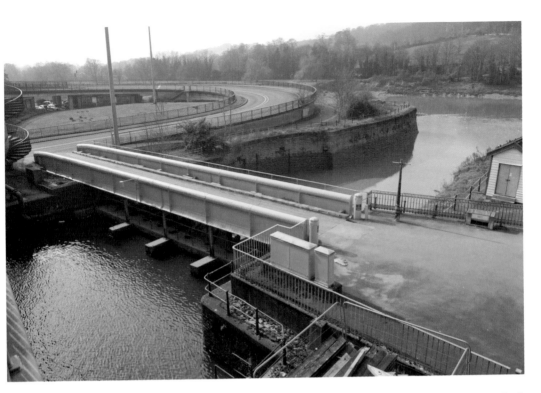

A great view looking down at the South Entrance Lock from the Plimsoll swing bridge which carries the A3029 from Long Ashton into Hotwells. *Below*: Illustration of IKB's dock gates published in the 1870 biography of IKB, written by his son, another Isambard Brunel.

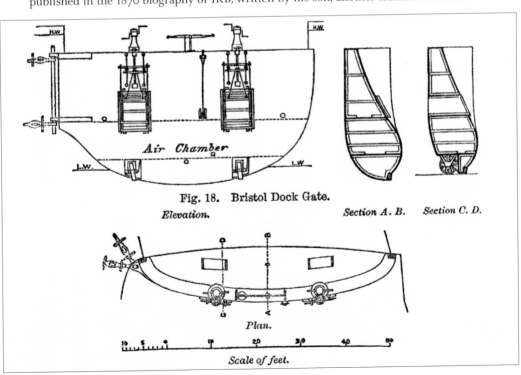

Fig. 18. Bristol Dock Gate.

Elevation. Section A. B. Section C. D.

Plan.

Scale of feet.

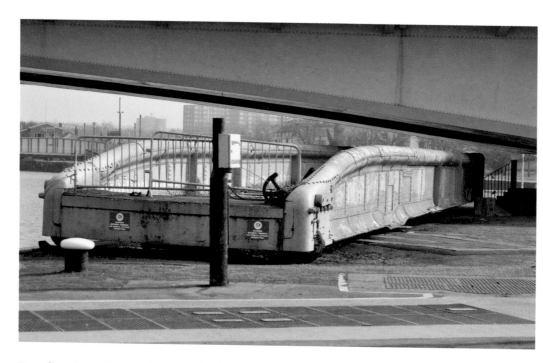

Brunel's tubular iron girder swing bridge. This was originally located on his South Entrance Lock, but cheekily appropriated by Thomas Howard for his New Entrance Lock in 1873. It might look neglected but this is a genuine and historically important Brunel bridge. When these photographs were taken in 2013 the bridge had been stripped of its wooden decking, but this does reveal part of the rotating mechanism.

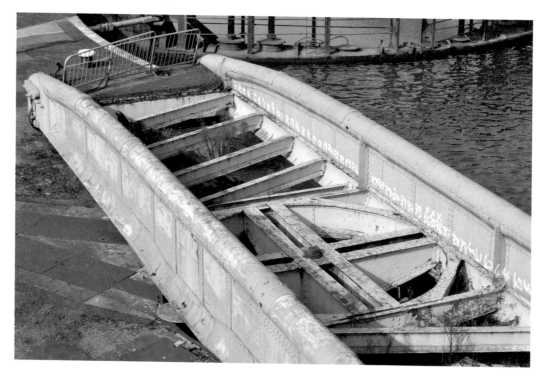

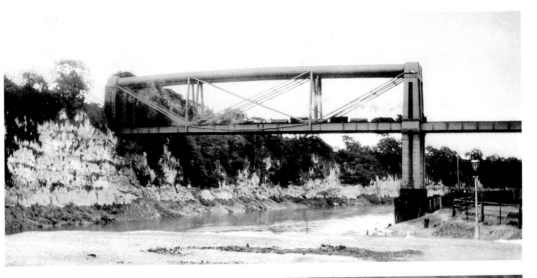

Brunel's experiments with wrought iron construction using tubular girders, pioneered with the little bridge over his South Entrance Lock at Bristol, led directly to the Chepstow railway bridge over the River Wye, *above*, and ultimately to his greatest iron bridge, the Royal Albert Bridge over the River Tamar at Saltash, *below*. It is very fortunate that the tubular bridge at Bristol has survived when it might have so easily been scrapped.

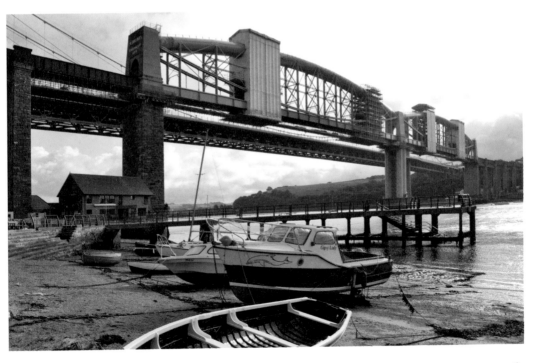

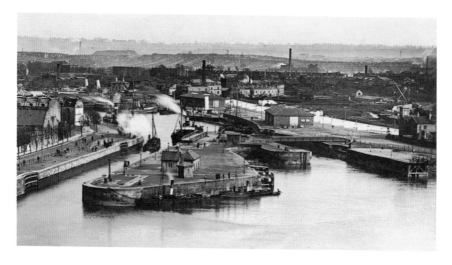

An early postcard view of the entrance locks into the Cumberland Basin, showing the original and duplicate tubular bridges. The indentation between the two locks is for a gridiron.

girders. It was the direct predecessor to the full-scale tubular bridges at Chepstow (1849) and the Royal Albert Bridge over the Tamar at Saltash (1859).

Brunel's South Entrance Lock did not remain in operation for very long. In 1873 the docks engineer Thomas Howard constructed the larger New Entrance Lock on the northern side of the entrance. To save money he pinched Brunel's swing bridge for his lock as he considered the old one to be redundant. When the boat operators complained the corporation agreed to keep the south lock operational and Howard dusted off IKB's drawings to create a replica bridge. This is the bridge fixed in position on Brunel's South Entrance Lock, while the original is now beside the north lock in the shadow of the modern Plimsoll swing/road bridge.

Other works

In 1841 Brunel was consulted regarding the establishment of the Clifton Water Works which was to tap a natural spring in the Avon Gorge. A pumping station was built at Black Rock with a slender chimney in the Italianate style. However Parliament favoured a later scheme by the Bristol Water Works Company to draw on the waters of the Mendip Hills. This rival absorbed the Black Rock works and in 1864 Brunel's pumping station was demolished to make way for a railway line passing through the Gorge to Avonmouth.

In addition to these water-based schemes, in 1850 Brunel was consulted by the Dean of Bristol Cathedral regarding concerns over the fabric of the building. He was also active in advocating the construction a deep water floating pier, to be located at Portishead, in a bid to restore Bristol's position in the transatlantic trade. This project, and a subsequent plan for the establishment of the Portbury

Pier & Railway Company were abandoned by the 1850s. Interestingly while these schemes were being mooted Brunel wrote to the trustees of the unfinished Clifton Bridge in April 1845 to allay their anxieties concerning his loyalties, and this letter provides us with an insight into how he regarded the city:

> ... Paternal affection made me determined to do everything I could for Clifton Bridge which must and shall be finished ... if one can't have a Portishead line that will benefit the bridge ... we must have some other ... for I quite agree with you that all hands must pull together for our reverend parent the City of Bristol.

Explore Brunel's Bristol dock works

• Brunel's South Entrance Lock into the Cumberland Basin, with its curved bottom, best seen at low tide, is easily accessed on foot beside the modern A3029 Plimsoll road bridge. The lock gates have been replaced and the tubular girder bridge is a copy, the original has been moved to the dockside next to the north lock.
• The Underfall Yard is a marvellous survivor from the working days of Bristol's docks and many of the buildings date from the nineteenth century. It is located between the Floating Harbour and the New Cut.
• Nothing remains of the Black Rock Pumping Station in Avon Gorge.

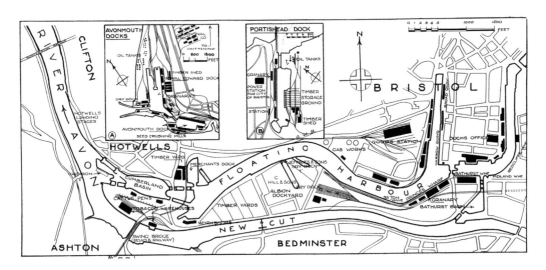

Lloyd's of London plan of the Bristol Docks from the 1930s. *(CMcC)*

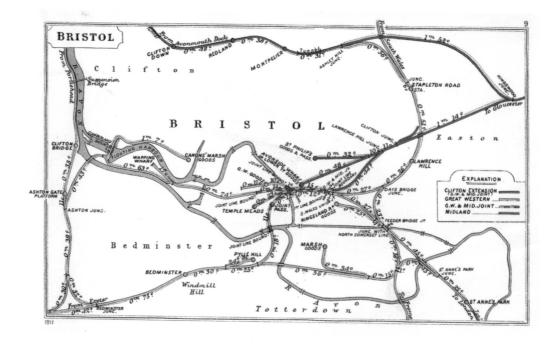

Railway diagram of Bristol area, 1911. Temple Meads is in the centre and the four main lines can be traced radiating away from it. Starting at the top: The former B&SWUR line to the New Passage ferry, and later the Severn Tunnel, curves upwards through Stapleton Road. The straight green line of the Bristol to Gloucester heads off to the north-east. GWR main line is in yellow and enters from the south-east or bottom right. The former B&ER is also in yellow and goes through Bedminster before heading to the south-west, bottom left, on its way to Exeter. *Below*: A vision of the future *c.* 1830s, with a B&ER train passing through the Ashton Vale and, in the distance, the Clifton Suspension Bridge even though this remained unfinished until the 1860s. *(CMcC)*

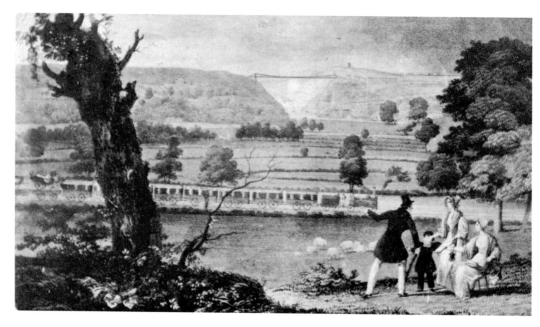

Bristol & Exeter Railway

In addition to the GWR, Brunel was engineer to three other Bristol railways. They were, in order of opening, the Bristol & Exeter Railway and the Bristol & Gloucester Railway which both opened in 1844, and the Bristol & South Wales Union Railway of 1863. All three terminated at Temple Meads which is where we begin.

The Bristol & Exeter Railway

Visitors arriving at today's Temple Meads station can't fail to notice the imposing building located to the right of the approach road and standing apart from the main station. This is the former office building for the Bristol & Exeter Railway which shared the site, with its own station at right angles to the GWR terminus. It was not unusual for railway companies to share sites and the obvious advantage was the ease of connection between the two lines.

As with the GWR the B&ER railway was built to the broad gauge – *see End of the Broad Gauge on page 85*. Of the line itself, as was customary for Brunel he was assisted by an extensive support team. However, he abhorred the term 'consultant engineer' and instead played the starring role as 'Engineer in Chief' in the same way that many modern architectural practices operate. The head man might oversee the projects and accrue the glory, but the more laborious and mundane work, the leg work of surveying and the time-consuming preparation of countless drawings, was carried out by others working under his direction. That's not to say that Brunel wasn't a hands-on engineer or was afraid to get his hands dirty, on the contrary there are many accounts of him getting stuck in to even the dirtiest of jobs, but as his empire spread even he couldn't be everywhere. The result is that many works are attributed to Brunel when the bulk of the work was carried out by others.

In 1836 Brunel called upon William Gravett to take charge of the surveying of the B&ER line. (Gravett had worked under Brunel on the Thames Tunnel and both men were awarded the Royal Humane Society's silver medal for saving the life of a workman following the first flooding of the tunnel on 18 May 1827.) He was subsequently promoted by Brunel as resident engineer on the first half of the line as far as Taunton and seems to have enjoyed an unprecedented degree of autonomy. At least at first. After a falling out – notably over problems with the wide brick-built 'Somerset' bridge over the River Perret south of Bridgwater – Brunel sacked him in 1841.

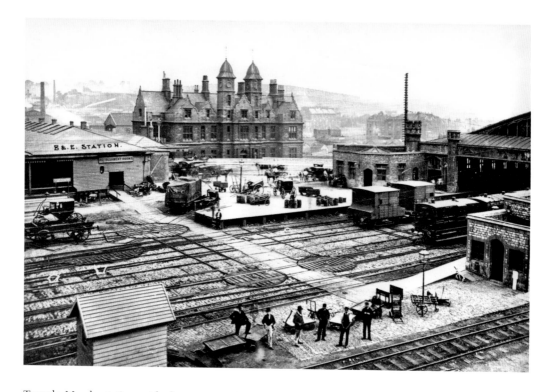

Temple Meads station with the entrance into Brunel's GWR terminus on the right, and the B&ER station at right angles going off to the left. The imposing building with the twin towers is the B&ER's headquarters.

Tracing the B&ER

The B&ER's terminus at Temple Meads was a simple timber-built structure on the eastern side of the GWR's station, known derisively as the 'cow shed'. It is shown in a famous photograph of the site taken in 1870, not long before it was swept away as part of the major extension of Temple Meads. The one obvious survivor of the B&ER seen in that photograph is the company's headquarters. Non-Brunellian, it was designed by Samuel Frip in a Jacobean style and built of honey-coloured Bath stone, with two sturdy towers. It was completed in 1854 and now beautifully restored it is offered as office accommodation, although the building appears to be largely unoccupied at the present.

From Temple Meads the B&ER line heads southwards over the River Avon before curving to the south-west. When this first section of line opened in 1841, only as far as Bridgwater initially, the first station out of Bristol was Ashton. This was actually a double station with Ashton, which was re-sited and reopened by the GWR as Bedminster station in 1871, and the Long Ashton Platform which became Long Ashton in 1929. These changes mean that Bedminster is now the first station on the line, barely a mile from Temple Meads. To further complicate matters it was moved further to the west in 1884 and rebuilt in 1932. This version of Bedminster is still open and is managed by

First Great Western. Long Ashton, meanwhile, was closed in 1941 and part of the site now lies under the A370.

The next station is Flax Bourton, which is at the furthest extent of this book's territory around Bristol. Located in North Somerset it is just over 5 miles from Temple Meads. It was a late addition to the B&ER as it opened in 1866 as Bourton station, and was only renamed as Flax Bourton in 1888. On 13 Oct 1876, Bourton cutting was the scene of a fatal railway accident when the Flying Dutchman passenger express from Exeter derailed. The locomotive was driven into the steep bank and then toppled back onto the train carriages. The engine driver, William Dunscombe of Bristol, died of his injuries shortly afterwards. His stoker, a man named Randall, suffered an instant death when, as the next day's newspaper reported, 'he was almost disembowelled and the back of his head cut off'.

At Flax Bourton there are remains of the station and goods shed buildings, however these are not original and date from the 1893 rebuild which saw the station shifted slightly further west where there was more space. The station was chopped by Beeching's Axe in 1964, although there are calls from local groups to have it re-opened.

Designed by the B&ER's Samuel Frip, the B&ER headquarters at Temple Meads were built in a Jacobean style. Non-Brunellian maybe, but a fine survivor from the formative years of Bristol's railways nonetheless.

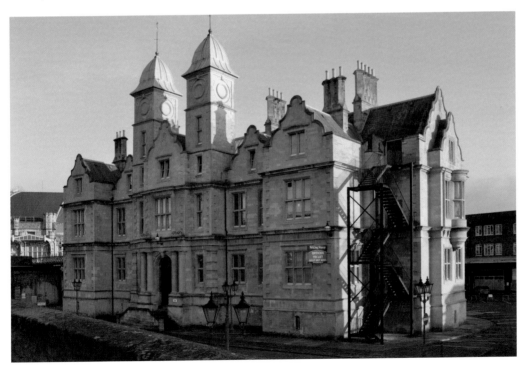

Beyond Flax Bourton the old B&ER continues on a level and almost dead-straight line to Bridgwater. It was extended as far as Taunton in 1842, and the completed line to Exeter opened in 1844. The B&ER was amalgamated with the GWR in 1876.

Explore the Bristol & Exter Railway

- The B&ER's headquarters building is at Temple Meads, Bristol.
- There is nothing to see at Bedminster or Long Ashton. The former was relocated and rebuilt, twice, the latter was closed in 1941 and the site is partially under the A370. (OS map 172, ST 548700)
- Flax Bourton is not an original B&ER station as it was relocated, slightly to the west, and the present derelict buildings date from 1893. They can be seen from the cycle path going eastwards from Station Road on the south side of the track, or by turning down a lane from the B3130 Clevedon Road. (OS map 172, ST 513698)

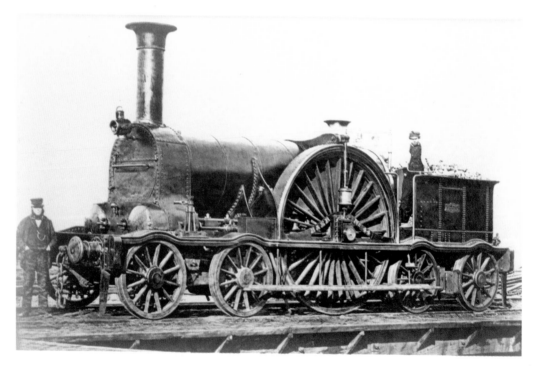

The B&ER was built to IKB's broad gauge. This 4-2-0T locomotive from 1854 was designed by the company's engineer, James Pearson, and built in Bolton by Rothwell & Co. It features massive 9 foot flangeless driving wheels between the two bogies.

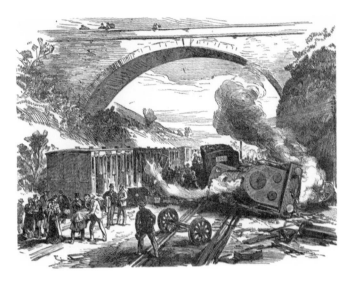

Yesterday, shortly after mid-day, a shocking accident occurred to the Flying Dutchman, the express train which travels between Paddington and Plymouth, and is due at Bristol from Exeter at four minutes past noon. It was in charge of the oldest guards in the company's employ, and a skilled engine-driver, William Dunscombe, of Bristol. It consisted of broad-gauge engine and tender, a guards' van, and five carriages containing about 150 or perhaps more than that number of passengers. Four miles from Bristol, in a long and deep cutting near Bourton, the engine suddenly mounted the top surface of the inner rail, ran along for a dozen yards, jumped off the track altogether, and the chain which coupled it to the van, and the rest of the train being severed, dashed along the six-foot way for 30 yards. The iron rails and the wooden transomes were considerably damaged. Then, becoming still more erratic in its course, it cut completely through the down line, dashed onwards for about 50 yards further, and plunged into the precipitous bank, falling back on to the line. With the force of the rebound it reared up, turned completly over lengthwise, and sent the tender several yards up the line, with its framework battered. William Dunscombe, the driver, and Randall, the stoker, kept their places till the last, and were only thrown off when the engine dashed into the bank. Randall was almost disembowelled, and the back part of his head was cut off. Dunscombe had his arm and leg cut off, and lived only about twenty minutes. As the engine turned over it was being passed by the van and passenger carriages, which had been kept to the rails. The van after dashing and swaying about a dozen yards past the engine suddenly turned at right angles, swerved across the line, and fell over; its sides were at the same time crushed by the heavy wheels of the engine, which, though weighing several tons, were sent flying through the air as the engine turned over. The guard, Thomas Watts (who lives at Long Ashton), had previously jumped out, and thus saved his life, but had his arm broken. The first carriage behind the tender had its hinder part smashed. The next to it was quite wrecked its windows were broken, and the passengers inside received severe cuts about the face, neck, head, and arms. One lady lost the sight of one eye. When extricated they were staunching their wounds with their handkerchiefs. They were not considered to be dangerously wounded. Most of the wounded passengers were taken to Long Ashton, and received there most hospitably by the villagers; others with slight wounds proceeded to Bristol. In the meantime steps were taken to clear the up and down lines. This was the work of considerable difficulty, and throughout the afternoon and evening passengers up and down had to be passed over the wreck by the officials to trains at either end of the blocked portion of the line.

On 13 October 1876 the Bourton cutting was the scene of a fatal accident when an express train from Exeter was derailed. The broad gauge locomotive was driven into the steep sides of the cutting and fell back onto the train carriages. The driver, a Bristol man, and his stoker were killed as a result of the accident, as reported in gruesome detail by the newspapers. *Below*: The later non-Brunel station building at Flax Bourton.

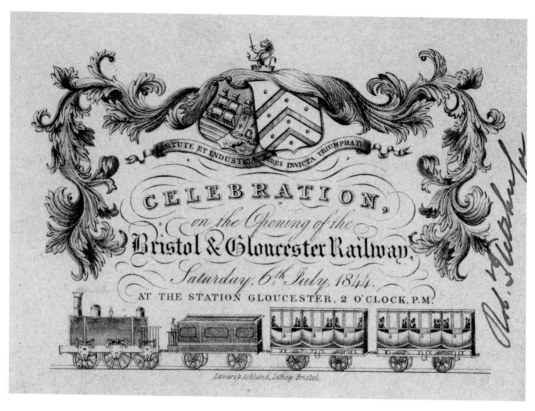

Invitation to the celebration marking the opening of the Bristol & Gloucester Railway on 6 July 1844. Services commenced two days later. *(CMcC)* The railway was short lived and merged with the Birmingham & Gloucester Railway the following year. *Below*: Mangotfield station photographed in 1954, with the line to Gloucester on the left. *(Colin G. Maggs)*

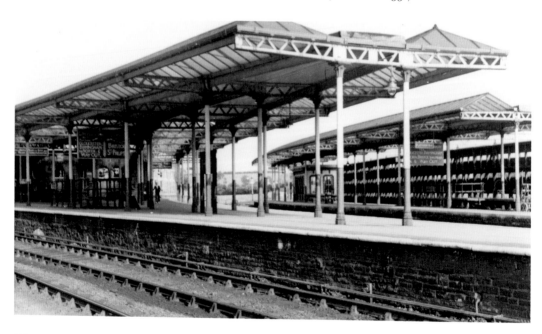

Bristol & Gloucester Railway

The Parliamentary Act for the Bristol & Gloucester Railway was passed in 1839. There had been several earlier proposals to build such a railway linking Bristol with the Midlands and the north. In the first flush of interest in railways, back in the 1820s, a scheme for the Bristol, Northern & Western Railway was put forward though never acted upon. The first lines to be constructed north of Bristol were a pair of tramways built between 1832 and 1835 to serve the south Gloucestershire area. These were the Avon & Gloucestershire and the Bristol & Gloucestershire. Built to carry horse-drawn coal wagons, they were known collectively as the Coalpit Heath Dramway. They extended from Bristol's Floating Harbour up to Mangotsfield.

The Bristol to Gloucester Railway was to have been built to the narrow gauge – only later known as the standard gauge – but once Brunel was on board as engineer he used his influence to convince the directors that the broad gauge would serve them better. This wasn't just a case of his persuasive personality winning the day; there were genuine practical considerations as the line was to join with the Cheltenham & Great Western Union Railway's broad gauge metals, coming across from Stroud, at Standish, for the final leg into Gloucester.

The initial section of rails from Brunel's GWR Bristol terminus at Temple Meads were laid on the old Dramway as far as Mangotsfield, although this section was closed in January 1970. The railway now diverts westwards at Westerleigh Junction and enters the city via Bristol Parkway and Filton. Heading northwards, the six stations on the Bristol & Gloucester were at Yate, Wickwar, Charfield, Berkeley Road, Frocester and Stonehouse (Bristol Road).

Yate

The first station, Yate, is about 7.5 miles (12 km) to the north-east of Temple Meads, and originally featured a typical Brunel chalet-style main building on the down platform (going to Bristol), with a shelter on the opposite side. The main part of the station was located south of the bridge on the A432 Station Road, in the western part of the town. Yate was only a small community at the time of the railway's arrival but saw considerable subsequent growth in mining and quarrying. The station was closed in January 1966, just at the time when Yate was being re-modelled as an overspill commuter town for Bristol. It reopened in May 1989, but by then the main station buildings had been demolished. Fortunately Brunel's brick-built goods shed escaped the bulldozers and it now serves as premises for a local company. The modern Yate station is split by the bridge of the main road with parking and access to Bristol-bound trains on the north side. To reach the south platform, where trains arrive from Bristol heading north to Gloucester, you need to cross over the busy road. From here you get an excellent view of the old goods shed with its twin doors facing

southwards, and on the western elevation overlooking the rails there are three pointed arch window surrounds in-filled with stone. On the eastern elevation it has a full-height opening for road vehicle access.

The 7.5 mile (12 km) branch line to Thornbury started a little to the north of the station at Yate. Built by the Midland Railway, it opened in 1872 but the under-used line closed to passenger traffic in 1944.

To Gloucester

Although the line to the north of Yate is beyond the remit of this book, a summary of the major features of the railway is of interest. (You will find a more detailed description in the companion volume, *Brunel in Gloucestershire*.)

Around 3.5 miles (5.6 km) north of Yate the railway enters a cutting leading into the Wickwar Tunnel which passes beneath the higher ground west of the village. The tunnel is 4,203 feet (1,281 metres) long and its course is marked on the surface by five ventilation shafts. It emerges on the northern edge of the village onto a curve leading directly to the former site of Wickwar's station. There is no station nowadays, but in its prime Wickwar had typical Brunellian buildings on the narrow down platform. In addition there were sidings and a goods yard on the northern side. Only the stationmaster's house remains, on the far side of the track.

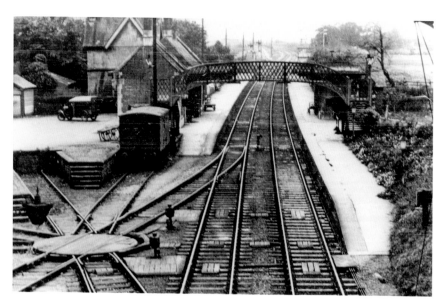

Yate station viewed from the road bridge in 1935, looking towards Bristol. The turntable on the left leads to sidings and the goods shed. Alas the old Brunel station was swept away after the line closed in 1966, just at the time when the town was expanding. (*Colin G. Maggs*)

An overlooked Brunellian gem, the goods shed at Yate with two track entrances facing southwards, and a vehicle entrance to the yard on the far side. Like many former goods sheds it now serves as commercial premises.

The next station is at Charfield where the buildings stand as unique surviving examples on this line of Brunel's Tudor Gothic style. The stationmaster's house is occupied, but the former booking office, waiting rooms and parcel office are now boarded up and surrounded by a Land Rover dealership which has also incorporated the later shed on the western side. The platform is no longer accessible, although as with many of the country stations there is talk of reopening it as a working station at some time in the future. Originally there were additional buildings on the down platform, plus sidings to the north and south side of the station. The red-brick rectangular water tower at the eastern end is a much later addition, as was the nearby signal box which has since been demolished. In 1928 Charfield station was the scene of a terrible train crash when, on the morning of 13 October 1928, a southbound Leeds to Bristol LMS night mail overran signals and collided with a freight train manoeuvring into the sidings. Fifteen people are known to have died in the accident.

The next stop is at Berkeley Road station, tucked away behind trees beside the bridge over the A38 Bristol to Gloucester main road. In its day this was one of the most important stations on the line as it is located roughly halfway between the towns of Berkeley to the north-west and Dursley/Cam to the east. When opened the station was known as Dursley and Berkeley Road until the short Dursley & Midland Junction Railway branch line opened in 1856. The original Berkeley Road station had the usual compliment of Brunellian structures with a chalet style main building on the up platform to Bristol and simple shelter on the other side. Post-Brunel, in 1875, a branch was extended

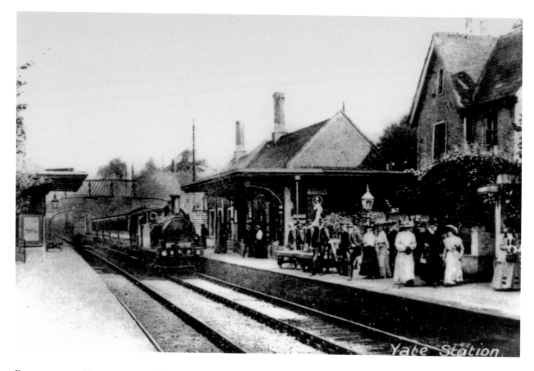

Passengers at Yate awaiting the arrival of the down train to Bristol. The road bridge can be made out in the distance behind the footbridge. *(Colin G. Maggs)*

westwards to the new docks at Sharpness, stopping at Berkeley itself on the way. With the completion of the Severn Railway Bridge in 1879 this became an important through route across the river to Lydney and a new set of platforms was built just to the north side of the old station. Berkeley Road's glory days came to an abrupt end following the loss of the Severn Railway Bridge in 1960. All passenger services were withdrawn in November 1964. Only the stationmaster's house, attributed to Brunel, remains.

Situated halfway between Berkeley Road and Stonehouse (Bristol Road), there is Frocester, one of the smallest stations on the Bristol & Gloucester and also the least used. All signs of the former station buildings on the east side of the track have been obliterated apart from the stationmaster's house.

Continuing northwards towards Stonehouse, Brunel took the rails over the River Frome at Beards Mill on one of his timber viaducts. This consisted of ten 50 foot (15.2 metre) main spans with a shorter 20 foot (6 metre) approach span on either side, giving an overall length of 540 feet (165 metres). Its maximum height was 43 feet (13 metres). The viaduct was replaced by a blue-brick and iron viaduct in 1884 and the present structure is in itself a very impressive.

The Bristol & Gloucester's Stonehouse (Bristol Road) station – so named to avoid confusion with the C&GWR's Stonehouse (Burdett Road) – was located just beyond the A419 Bristol Road. On the north side of the Stonehouse (Bristol Road) station there was a junction for the Stonehouse & Nailsworth Railway

which had its own platform, known as the 'donkey' station. Stonehouse (Bristol Road) closed for passenger services in 1965. With the exception of the stationmaster's house, all of the other buildings including the booking hall, signal box and goods shed, were demolished in the 1970s.

Merger

The Bristol & Gloucester Railway opened on 8 July 1844. It was an inauspicious start as the inaugural passenger train derailed just short of Gloucester station, resulting in the passengers having to clamber out and walk the final mile or so. In 1845 the Bristol & Gloucester merged with the Birmingham & Gloucester Railway to form the Birmingham & Bristol Railway. It was a short term marriage as the company was absorbed by the Midland Railway the following year. As a result Parliament granted consent for the Midland Railway to extend its narrow gauge rails all the way to Temple Meads, the heart of Brunel's broad gauge network.

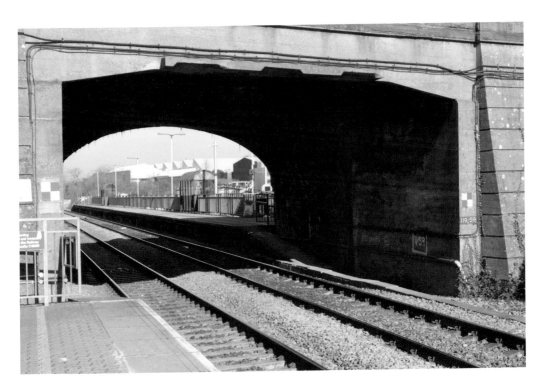

Today's Yate station is a bleak place with only an infrequently manned booth to serve passengers, and the two platforms divided by the road bridge and the busy road.

Top left: Looking down towards the station at Wickwar, showing the sidings, goods shed and the brewery buildings. The stationmaster's house has survived, as has the brewery, but the station itself is gone.

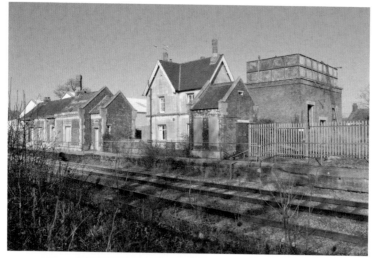

Left: Charfield is a fantastic example of a Brunel-era station on the Bristol to Gloucester line. The stationmaster's house is occupied, but the station buildings are boarded up. Hopefully they might be reused one day.

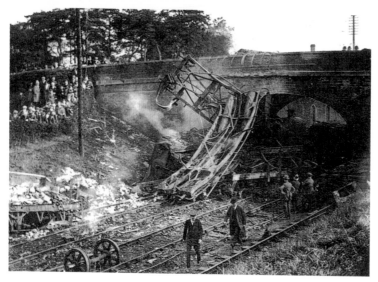

Lower left: On 13 October 1928 there was a collision between two trains at Charfield, resulting in the deaths of fifteen people, including two victims who remained unidentified. Such was the severity of the crash that wreckage was thrown up to the level of the road bridge.

- Not much to see at Yate apart from the original goods shed (OS map 172, ST 702826).
- Wickwar: Good view of the tunnel's south portal from Brunel's road bridge. From here you can take the path to a foot bridge (OS map 172 ST 71387). Ventilation shafts are best seen at King George V playing fields (OS map 172 or 162 ST 719885). North portal and site of former station is on the B4060 Wickwar Road (OS map 172 or 162 ST 727891). There are two of Brunel's skew bridges passing over the road just to the north.
- No direct access to Charfield station, it can be viewed from the road opposite or from the pedestrian bridge (OS map 162, grid ref ST 723923). A memorial to the victims of the 1928 accident is at the rear of St James's in Churchend, south of Charfield (OS map 162, grid ref ST 719912).
- Berkeley Road Station: Only the stationmaster's house remains. Off the A38 opposite the Prince of Wales pub and junction with the B4066 Berkeley Road (OS map 162, grid ref ST 713963).
- Frocester Station: Little to see. Viewed from the road bridge the stationmaster's house is to the left – now a private residence.
- Stonehouse: The station may have gone but the viaduct at Beards Mill is well worth seeing. Vehicle access restricted from the south, but a pleasant walk from either direction (OS map 162, grid ref SO 797050).

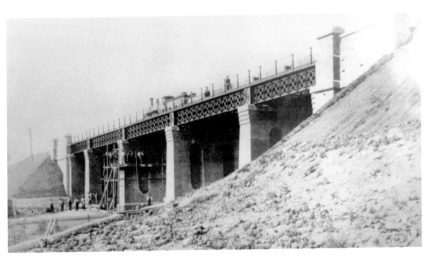

The viaduct at Beards Mill, over the River Frome just to the south of Stonehouse. 540 feet long, this was one of Brunel's timber viaducts until it was replaced by the present structure in 1884.

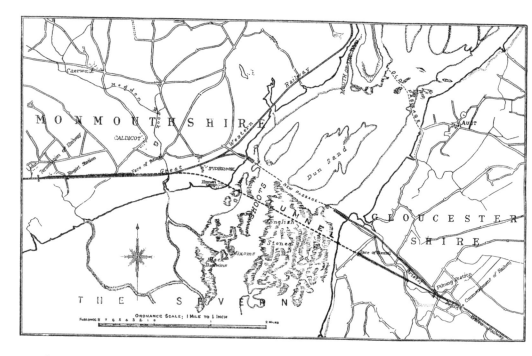

Map showing the route of the Bristol & South Wales Union Railway, including the ferry crossing shown as New Passage, just below the Dun sandbank. The later Severn Tunnel, which was completed after fourteen years of work in 1886, is shown to its south. *Below*: The stone abutment for IKB's wooden pier at New Passage. It had to be so high to allow for the river's extreme tidal range. The trains continued onto the pier itself.

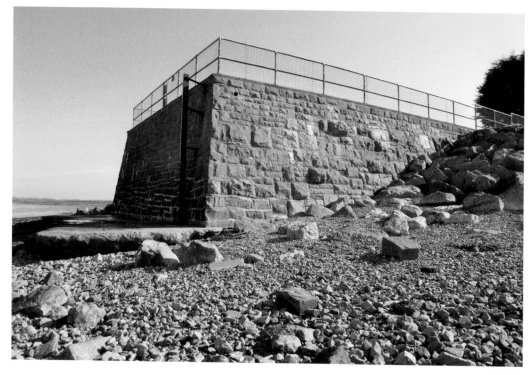

Bristol & South Wales Union Railway

Although Bristol and South Wales are tantalisingly close to each other they are divided by the Severn Estuary, and until the advent of a direct crossing by bridge or tunnel – Brunel had advocated both but his plans for a bridge over the river near Arlingham were thwarted by the Admiralty and he recognised that a tunnel was still some years off – the quickest route was by rail with a 50 mile detour going via Gloucester where the river narrows. There was an alternative, a more direct route that would incorporate a railway from Bristol with a transfer to a ferry for the crossing to the Monmouthshire side of the Severn to catch another train on the other side.

When the Bristol & South West Junction Railway (B&SWJR) was authorised by Parliament in 1846, Brunel was appointed to survey the route. There were two existing ferry services at that time; one at Aust, known as the Old Passage, and a rival ferry at New Passage, about 2 miles (3 km) further south, which went to Black Rock near Portskewett on the Monmouthshire side. As the New Passage ferry service was in decline the railway company decided to buy it, but subsequently failed to raise sufficient funds for the construction of the connecting railway line. A few years later, in 1854, a second scheme known as the Bristol, South Wales & Southampton Union Railway (BSW&SUR) proposed building a similar line from Bristol, this time going westwards along the Avon Gorge and up to New Passage to connect with the ferry. This scheme eventually became the Bristol & South Wales Union Railway (B&SWUR) and received parliamentary assent in 1857 for an alternative more northern route out of Bristol.

With Brunel as engineer the 12 mile (18 km) single track line was, inevitably, broad gauge. It branched from the GWR rails north of Temple Meads to turn north-westwards towards the Severn, with intermediate stations at Lawrence Hill, Stapleton Road, Ashley Road (added in 1864), Horfield, Patchway, Pilning, New Passage and terminating at the New Passage Pier. (More stations were later added by the GWR at Horfield, Pilning Low Level, Cross Hands Halt, and New Passage Halt.) At New Passage Brunel created a substantial timber-built pier extending out from a stone abutment. It was 1,638 feet (499 metres) long and stood on high timber piles to deal with the river's notoriously large tidal range. The trains ran to the end of the pier itself where passengers would alight and descend via staircases to pontoons from which they would board the steamers. A report published in *The Illustrated London News* at the time of the service's opening provides a more detailed description:

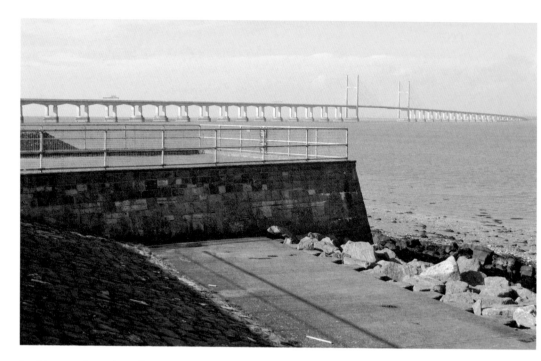

Looking southwards with the abutment in the foreground and the Second Severn Crossing which was completed in June 1996. *Below*: This cast iron plaque was originally positioned over the portal of the Patchway Tunnel and is now on the wall on Platform 1 at Temple Meads. It credits Brunel as the engineer even though he had died four years earlier, the work being completed by his former assistant Robert Brereton.

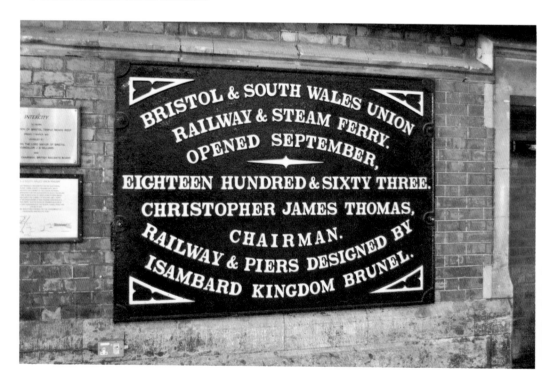

The piers at the Severn, undoubtedly the most interesting works on the line, are formed of creosoted timber, and the construction of both piers is the same, with the exception of the foundations, which on the New Passage side consist of piles driven firmly into the ground till they reach the rock below, which exists at a depth of from 6 feet to 20 feet. The superstructure is carried on upright timbers, braced together in couples, and standing in rows of five couples. There are upwards of seventy rows which are 22 feet apart, and connected at the top by longitudinal baulks corresponding with the uprights, on which the 5-inch planking carries the permanent way. The pier is erected to a height of 50 feet above low-water mark.

After Brunel's death in 1859 his long-serving and faithful assistant Robert Pearson Brereton took over the reins of the engineering practice – continuing to work from Brunel's London office for several years – and it was Brereton who completed the work on the B&SWUR, which opened on 8 September 1863. The fifteen-bedroom New Passage Hotel was built beside the pier to accommodate travellers and by all accounts overnight stays caused by conditions on the river were not uncommon. Many a stormy night was spent by passengers and boatmen in the hotel's bar. So while the rail and ferry link cut the Gloucester detour, savings in journey time were not always achieved. On the far side of the river the railway connected with the line from Gloucester to South Wales at Portskewett Junction.

In 1868 the B&SWUR was absorbed by the GWR, which had operated its trains from the outset. The line was converted to standard gauge in May 1872. By then work had already commenced on the Severn Tunnel, which descended under the river barely half a mile to the south of the New Passage pier. Railway sidings were laid at both New Passage and Portskewett for additional traffic connected with the sinking of the shafts and the tunnel workings, and a tall pumping house was erected to accommodate a steam engine to clear water out of the workings. The Severn Tunnel was an extraordinary piece of engineering. At 25,590 feet (7,800 metres) it remained the longest railway tunnel in the UK until the Channel Tunnel opened in 1994. Rail access through the tunnel was created via a branch extending from the line at Pilning. The day after the tunnel opened for passenger services, on 30 November 1886, the ferry and section of line from Pilning to New Passage ceased operation.

The B&SWUR was also authorised to construct a line from the proposed new dock at Avonmouth in 1862, but neither were built. Then in 1900 the GWR reopened the section of line between Pilning and New Passage for goods traffic, connecting on a new route to Avonmouth. Commencing in the 1920s and continuing until 1964, passenger trains ran as far as Severn Beach and continued to new stations at New Passage and Pilning Low Level.

The New Passage Hotel continued to serve as a privately run public house.

In the 1920s the hotel's ballroom was the location of inventor H. G. Matthews' experiments in the projection of moving pictures coupled with a sound track. Bizarrely, Matthews also claimed to have invented a death-ray machine and is better remembered for this than his contributions to cinema. The hotel was closed in the early 1970s and later demolished to make way for a housing development. If you visit New Passage you can still see Brunel's stone abutment for the pier, and behind the new houses the ground rises to a hump indicating the line of the old railway which terminates at a house appropriately named 'Puffer's End'.

To this day the Severn Tunnel continues to serve as a major artery for rail traffic passing between England and South Wales. And standing on the restored stone abutment of Brunel's B&SWUR ferry pier, you can't miss the two modern road bridges.

Explore the Bristol & South Western Union Railway

• A large commemorative plaque, which originally adorned the eastern portal of Patchway Tunnel, is displayed on Platform 1 at Temple Meads, Bristol.
• At New Passage the stone abutment for the pier remains and you can walk along the riverside on the Severn Way footpath (OS map 172, ST 544864). The hotel has been demolished and a row of houses stand on the site. The course of the railway is indicated by the raised hump parallel to the road.

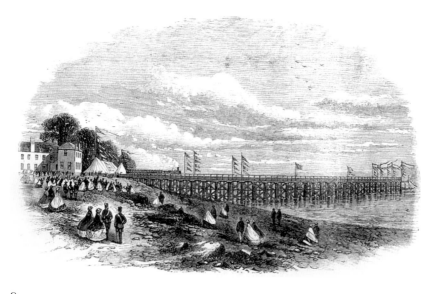

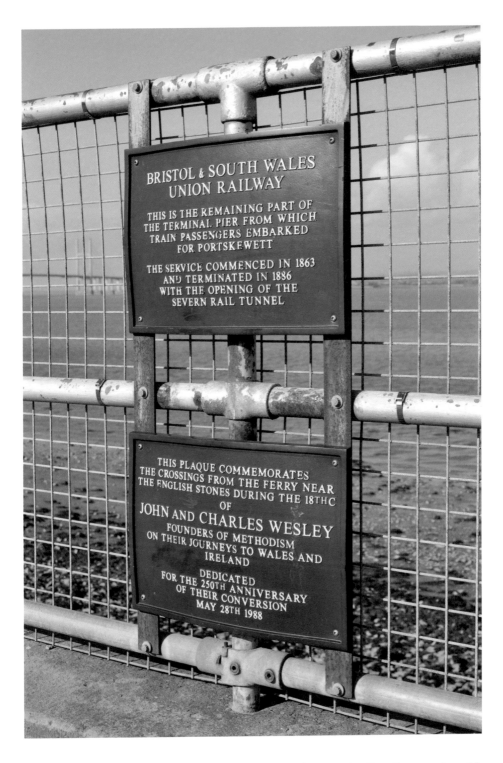

BRISTOL & SOUTH WALES
UNION RAILWAY

THIS IS THE REMAINING PART OF
THE TERMINAL PIER FROM WHICH
TRAIN PASSENGERS EMBARKED
FOR PORTSKEWETT

THE SERVICE COMMENCED IN 1863
AND TERMINATED IN 1886
WITH THE OPENING OF THE
SEVERN RAIL TUNNEL

THIS PLAQUE COMMEMORATES
THE CROSSINGS FROM THE FERRY NEAR
THE ENGLISH STONES DURING THE 18TH C
OF
JOHN AND CHARLES WESLEY
FOUNDERS OF METHODISM
ON THEIR JOURNEYS TO WALES AND
IRELAND

DEDICATED
FOR THE 250TH ANNIVERSARY
OF THEIR CONVERSION
MAY 28TH 1988

Opposite: 1863 illustration of the rail/ferry opening, showing the New Passage pier with the hotel on the left. *Above*: Not one but two commemorative plaques at the end of the abutment at New Passage.

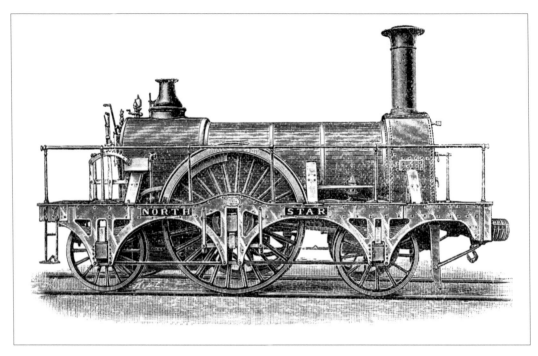

Built by Robert Stephenson between 1838 and 1841, *North Star* was the first locomotive to run on the GWR. A total of twelve 2-2-2 Star class locomotives were built. Along with the *Lord of the Isles* it was stored at Swindon until 1906 when it was scrapped. Some components have been reused in the replica at the Steam Museum. *Below*: Gooch's 4-2-2 Iron Duke class were the finest locomotives of the broad gauge era. The later version, introduced after 1871, was known as the Rover class. The *Bulkeley* was built in 1880 and retired in 1892.

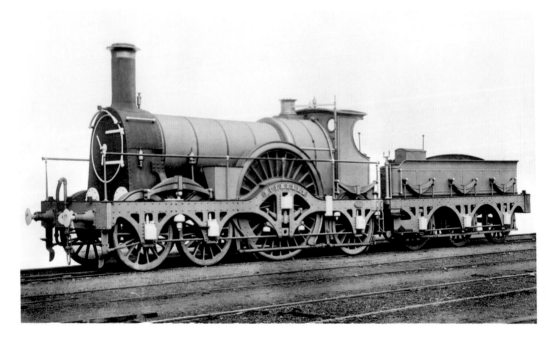

End of the Broad Gauge

When he was appointed as engineer to the Great Western Railway in March 1833, Brunel determined that it was to be the finest railway in Britain. At that point in the development of the railways there were no ground rules laid down by government regarding engineering details such as the choice of gauge - the distance between the rails. In the north of England George Stephenson had chosen the 4 ft 8.5 inch (1.4 m) gauge for the Stockton & Darlington Railway simply because it was already used in the collieries which it served, and naturally enough his son, Robert Stephenson, followed suit. That all seemed a long way from the Bristol to London railway, and Brunel dismissed the northern 'coal wagon' gauge in favour of a wider one at 7 ft and a quarter inch (2.1 m) as this would be 'more commensurate with the mass and velocity to be attained'. One of his early proposals had the railway carriages contained within the wheels rather than sitting above them to lower the centre of gravity, although this was not put into practice.

It has been suggested that Brunel chose a non-standard gauge for the sake of being different from his rivals, but whether or not this was the case the 'broad gauge', as it became known, was approved by the GWR board in 1835. Over the next ten years, from 1835 to 1845, the various railways spread their spidery fingers across the map of Britain and as we have seen Brunel selected the broad gauge for the Bristol & Exeter Railway, the Bristol & Gloucester Railway and the Bristol & South Wales Union Railway. At the extension of the rails beyond Exeter the broad gauge was also the obvious choice for the South Devon Railway and also the two Cornish railways all the way to Penzance. But don't forget that Brunel was not alone in adopting 'non-standard' gauges. About a hundred miles of the London & North Eastern Railway had been constructed to a gauge of 5 ft (1.5 m), some Scottish lines were laid with 4 ft 6 inch (1.3 m) or 5 ft 6 inch (1.7 m) gauges, the Surrey Iron Railway was of 4 ft (1.2 m) gauge, and there were several others examples such as the London & Blackwall Railway.

Opinion varied regarding the merits of the various gauges, both in terms of performance and the desirability of standardisation, but matters really came to a head at the point where differing gauges met. This happened for the first time at Gloucester, where the Midland Railway met an extension of the GWR. Brunel's solution to this 'change of gauge' issue was the transit shed, which had broad gauge track entering on one side of a central platform and 'standard gauge', as it was already being referred to, on the other. Passengers, luggage and goods had to be laboriously transferred from one train to the other. This resulted in pandemonium, as described by *The Illustrated London News*:

> It was found at Gloucester that to trans-ship the contents of one wagon full of miscellaneous merchandise to another, from one Gauge to another, takes

about an hour; with all the force of porters you can put to work on it... In the hurry the bricks are miscounted, the slates chipped at the edges, the cheeses cracked, the ripe fruit and vegetables crushed and spoiled; the chairs, furniture, oil cakes, cast-iron pots, grates and ovens all more or less broken... Whereas, if there had not been any interruption of gauge, the whole train would in all probability have been at its destination long before the transfer of the last article, and without any damage or delay.

The government called for a Royal Commission to decide on the matter. Forty-four witnesses gave evidence on behalf of the standard gauge, while the broad gauge was defended by only four, including Brunel and Gooch. Trials between the two factions were conducted with trains travelling between Didcot and London, and the broad gauge came out on top. Despite the fact that Brunel had won that battle he couldn't win the war as there were considerably more miles of standard gauge than broad. The commissioners recommended that for the sake of uniformity the 4 ft 8.5 inches (1.42 m) should be the gauge for all public railways. In 1846 the Gauge Act dictated that all new lines had to conform to the standard gauge, unless they were extensions to the existing broad gauge network.

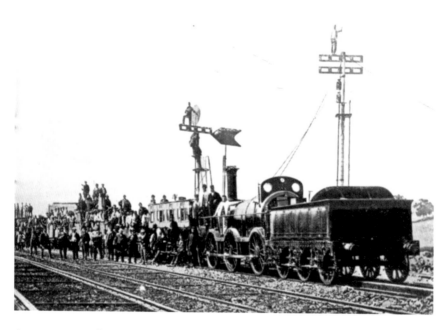

A gauge conversion train at Grange Court in August 1869. Note the disc and cross bar signals with some brave souls perched on top. The work on the 21.5 mile line between Grange Court and Hereford was carried out over five days and served as a test for the main conversion programme.

This famous illustration shows the chaos caused by the meeting of different gauges at Gloucester. In part it was published as part of the propaganda aimed at damaging the broad gauge's cause, but in truth the changeover from one train to another was a tedious and time wasting interruption to the through journeys.

To some extent the installation of a third rail to create mixed gauge lines enabled the broad gauge trains to keep working for several more decades. This had many drawbacks of its own, not least being the cost, and gradually the broad gauge lines were converted to standard. It was to be a slow, lingering death. Gradually the mixed and narrow gauge rails infiltrated the GWR's territory. On the B&ER, for instance, the section between Highbridge and Durston was converted to mixed gauge in 1867, and the remainder of the line had followed suit within six years. In 1892 all of the remaining 415 miles (668 km) of broad gauge, between London and Penzance, was converted over the weekend of 21 - 22 May.

For many observers the broad gauge represents a lost opportunity. A *Punch* cartoon portrayed the ghost of Brunel passing among the navvies as they carried out their work. Entitled 'The Burial of the Broad Gauge', it bade farewell with the words, 'Good-bye, poor old Broad Gauge, God bless you.' The directors of the GWR and the many Bristol investors in Brunel's railways were feeling less sentimental as Brunel's great broad gauge experiment had cost them dearly. It is fair to say that the decision of the Gauge Commission in 1846, combined with the calamitous failure of the Great Western Steamship Company following the *Great Britain's* grounding at Dundrum Bay, marked the end of Bristol's close relationship with Brunel.

If the city hadn't fallen out of love with its adopted son, he had certainly fallen out of favour.

Explore Brunel's broad gauge

• Apart from the railways and associated buildings from the broad gauge era, described in the appropriate sections, there are several replica broad gauge locos, although none of these is in Bristol: The *Iron Duke* replica is displayed at the northern terminus of the Gloucestershire Warwickshire Railway at Toddington – www.gwsr.com (OS map 150, SO 049324). At the GWR Steam Museum in Swindon there is the replica *North Star* which incorporates driving wheels from the original – www.steam-museum. org.uk. The GWR Society's Didcot Railway Centre in Oxfordshire has a working replica of Daniel Gooch's *Fire Fly*, plus a section of mixed gauge track and a transfer shed – www.didcotrailwaycentre.org.uk.

The final change from broad to standard gauge was carried out over the weekend of 21 - 22 May 1892. A team of navies is at work at Saltash converting the line which crosses over IKB's Royal Albert Bridge.

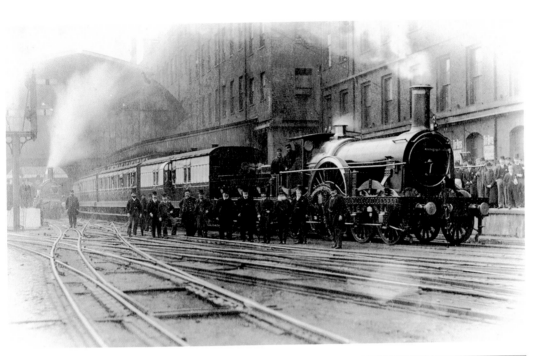

Above: Dignitaries pose in front of the last broad gauge passenger express to depart from Paddington. The Cornishman, hauled by the Rover class *Great Western*, left the station at 10.15 on Saturday 20 May 1892.

Right: Punch's surprisingly sentimental tribute to Brunel and the passing of the broad gauge in 1892. It was accompanied by a lament entitled 'The Burial of the Broad Gauge':

Not a whistle was heard,
* not a brass bell note,*
As his corse o'er the
* sleepers we hurried;*
Not a fog-signal wailed
* from a husky throat*
O'er the grave where
* our 'Broad Gauge' we*
* buried.*

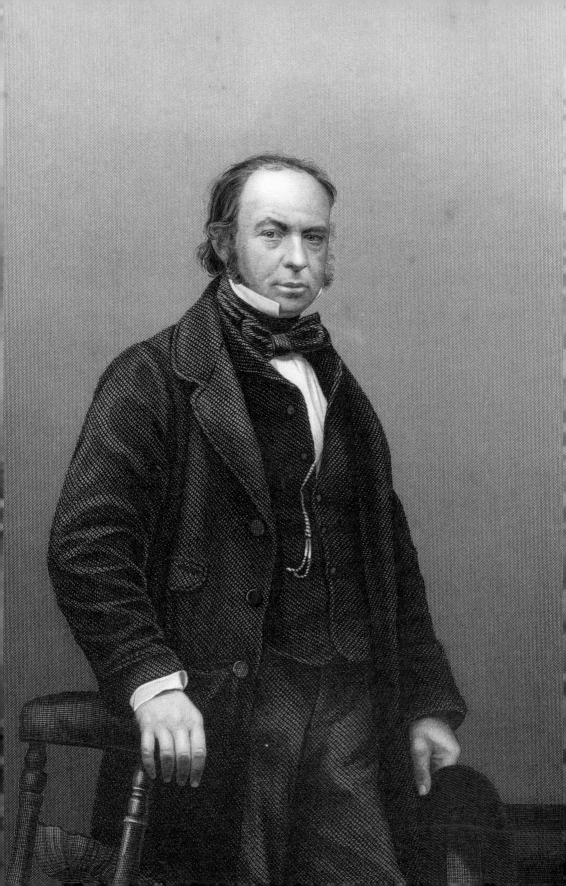

Brunel's Legacy

Brunel's legacy might seem obvious. He has given Bristol its most enduring icons, the Clifton Suspension Bridge, the *Great Britain* and Temple Meads. The bridge in particular has appeared on Royal Mail postage stamps, as a backdrop to regional television news programmes and as a logo for countless firms which have hijacked the Brunel name for every product you can imagine from finance companies to flower shops, from solicitors to scaffolding, pubs to plumbers, the list is endless. The *Great Britain* is the centrepiece of the rejuvenated harbour area and ranked by one visitor website as the city's No.1 attraction. Temple Meads might be less well known outside of the region but Brunel's railway connecting London with Bristol remains one of the finest in the world, and was the first railway to be considered for nomination as a World Heritage Site.

I expect Brunel would be surprised to see that so much of his work is revered so long after his death. He would certainly be amazed to discover that his vision of a transatlantic transportation link now exists in the form of direct flights from Bristol Airport to Orlando in the USA. But in the end Brunel's legacy is about more than the tangible aspects of the heritage industry. Brunel is not just a symbol for one city. Through his achievements he represents a spirit of innovation and a strength of conviction. Why else would he have come second

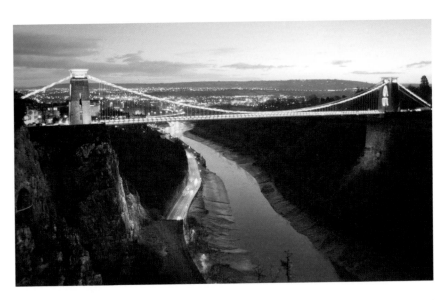

Clifton Suspension Bridge with the new lighting which was unveiled as part of the Brunel 200 celebrations in 2006. Flood lighting on the abutment and cliffs has enhanced the drama of the location.

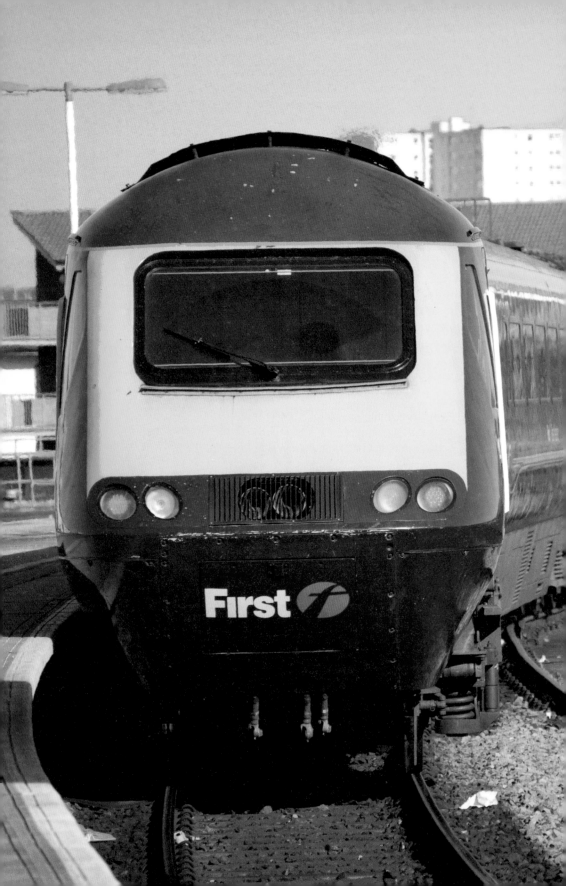

only to Winston Churchill in the popular poll for the 100 Greatest Britons? And why else would the figure of Brunel be the focal point of the opening ceremony of the 2012 London Olympics?

Without any doubt Bristol and Brunel are destined to be linked together for all time. What Bristol does lack is a decent statue of the man. When John Doubleday's statue was unveiled in front of the Bristol & West offices at the end of Broad Quay, just off the City Centre, in May 1982, it was greeted by titters from the invited guests. It is one of a pair by the sculptor. The other one at Paddington is a fine likeness of Brunel sitting in a chair, but Bristol has the one described by a critic as looking more like Charlie Chaplin, complete with cane, and another suggested it would look better elsewhere – at the bottom of the Bristol Channel. The statue has since been moved to a less prominent position at Temple Quay. The other thing the city needs is a proper Brunel museum. The display at the Bristol Museum on the docks is minimal but, in fairness, we do have the Brunel Institute which houses an extensive library and collection of artefacts. Part of its education programme is to nurture future Brunels. It is located alongside the *Great Britain*.

And as for *that* statue, the appearance of 'Isambark Kingdog Brunel' at Temple Meads in 2013 more than makes up for it. Conceived by Bristol's Aardman Animation and designed by illustrator Tim Miness, it was one of eighty specially decorated Gromit sculptures placed around the city in the Gromit Unleashed campaign to raise money for the Bristol Children's Hospital. Close, but no cigar.

Opposite: First Great Western HST 125 pulling into Temple Meads in 2013.

Right: 'Isambark Kingdog Brunel' at Temple Meads. This was one of eighty Gromits Unleashed in Bristol during the summer of 2013. *(Martin Booth, www.bristol-culture.com)*

93

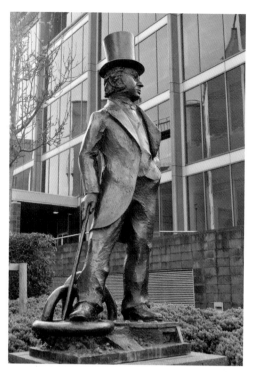 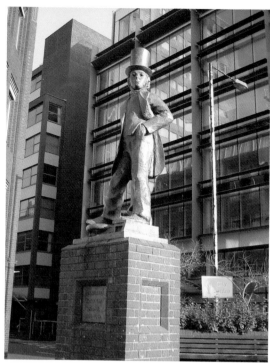

Above: John Doubleday's statue shown at its new setting at Temple Quay and as originally sited outside the old Bristol & West offices on Broad Quay. This statue had a seated counterpart at Paddington. *Below*: Detail from the 1959 commemorative plaque beside the Clifton Suspension Bridge, and Temple Meads reflected in the window of the former Reckless Engineer pub on Temple Way.

Brunel in Bristol: Chronology

1829	Nov: IKB submits designs for suspension bridge across Avon Gorge.
1830	January: First mention of IKB visiting Bristol, written in father's diary.
1831	March: Brunel wins second competition to design the bridge.
	August: Ceremony marking commencement of work on Clifton Bridge.
	October: Bristol riots, IKB enlisted as special constable.
1832	IKB commissioned by Dock Company to advise on improvements.
1833	7 March: IKB appointed engineer to Bristol Railway Company (GWR).
	27 August: Confirmed as engineer to the GWR.
1834	Completion of IKB's dredger for Bristol docks.
1835	31 August: Parliamentary Act for the GWR receives royal assent.
	September: Appointed engineer to B&ER and C&GWUR.
1836	Great Western Steamship Company formed.
1837	19 July: Launch of the *Great Western* steamship.
1838	7-23 April: First transatlantic voyage of *Great Western*, from Liverpool.
1840	31 August: The GWR's Temple Meads terminus is opened.
1841:	First GWR trains run from Paddington to Temple Meads.
	First section of the B&ER opens as far as Bridgwater.
1842	1 July: B&ER extended to Taunton.
1843	19 July: Iron-hulled and screw-driven *Great Britain* launched.
1844	1 May: B&ER opens all the way to Exeter.
	6 July: B&GR opens.
	10 December: *Great Britain* squeezes through Cumberland Basin lock.
1845	26 July: Maiden voyage of *Great Britain* to New York.
1846	22 September: *Great Britain* runs aground at Dundrum Bay, Ireland.
	The Gauge Act condemns the broad gauge.
1849	IKB's South Entrance Lock is completed.
1850	*Great Britain* sold to Gibbs, Bright & Co. of Liverpool.
1851	Chains intended for Clifton sold to be used on IKB's bridge at Saltash.
1857	*Great Western* steamship is broken up at Millbank, London.
1859	15 September: IKB dies at his home in Duke Street, London.
1863	8 September: Opening of the B&SWUR.
1864	8 December. Clifton Suspension opened five years after IKB's death.
1871–8	Major extension of Temple Meads.
1876	B&ER amalgamated with GWR.
1886	*Great Britain* stranded in the Falkland Islands.
1892	21-22 May: The last 177 miles of the broad gauge converted.
1965	IKB's original Temple Meads terminus ceases to be used by trains.
1970	19 July: *Great Britain* returns to Bristol.
2006	Brunel 200 celebrates the bicentenary of IKB's birth.

Also in this series:

Brunel in Gloucestershire – published 2012.
Brunel in London – published spring 2014.
Brunel in Cornwall – published summer 2014.

Further reading:

The Lost Works of Isambard Kingdom Brunel, John Christopher (Amberley Publishing, 2011).

The Bristol & Gloucester Railway, Colin M. Maggs (Amberley Publishing, 2013).

Brunel's Bristol, Angus Buchanan and Michael Williams (Redcliffe, 2005).

Brunel – In Love With the Impossible, Edited by Andrew and Melanie Kelly (Brunel 200, 2006).

Brunel – The Man Who Built the World, Steven Brindle (Weidenfeld & Nicholson, 2005).

Isambard Kingdom Brunel, L. T. C. Rolt (Longmans Green, 1957).

Isambard Kingdom Brunel – Engineering Knight Errant, Adrian Vaughan (John Murray, 1991).

Isambard Kingdom Brunel – Recent Works, Edited by Eric Kentley, Angie Hudson and James Peto (Design Museum, 2000).

The Life of Isambard Kingdom Brunel – Civil Engineer, Isambard Brunel (Longmans Green, 1870).

Acknowledgements:

I would like to thank the following individuals and organisations for providing photographs and other images for this book: Campbell McCutcheon of Amberley Publishing *(CMcC)*, the US Library of Congress *(LoC)*, Dick Warren, Martin Booth at Bristol Culture www.bristol-culture.com and Colin G. Maggs. Unless otherwise indicated all new photography is by the author. JC